Life doesn't come with a manual. It comes with a mom.

THE

PROJECT

ST. MARTIN'S PRESS ≈ NEW YORK

# the belly art project

moms supporting moms

100% of book author proceeds will help mothers in need.

SARA BLAKELY

Here's to **strong** women....
May we **know** them.
May we **be** them.
May we **raise** them.

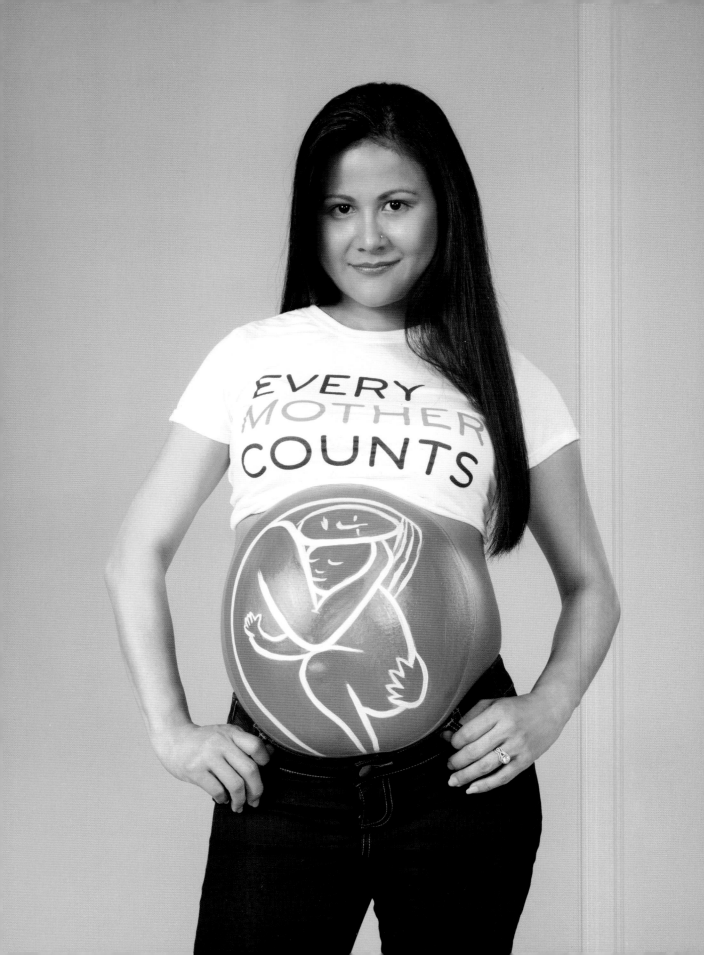

100% of
*The Belly Art Project*
book author proceeds go
to help mothers in need.

**Shirene Free**
date: 9.30.15, Atlanta, GA
photographer: Justin Keoninh
belly painter: Julie Hassett
hair/makeup: Kylie Bowles
videographer: Joshua
Rosenbaum

**Soleil Moon Frye**
date: 2.6.14, Los Angeles, CA
photographer: Meeno Peluce
belly painter: Ronit Horan
makeup: Suzi Haydon

**Sonequa Martin-Green**
date: 12.1.14, Los Angeles, CA
photographer: Stephanie Mathis
belly painter: Julie Hassett
set design/props: Brent Nieto
makeup: Carola Gonzalez

**Stacey Bendet**
date: 7.23.15, New York City, NY
photographer: Mallane Stanbury
belly painter: Michael Mejia
set design/props: Eyal Baruch
hair: Charles Amos
makeup: Jennifer Myles
styling: Alice + Olivia

**Stacy Keibler**
date: 7.15.14, Beverly Hills, CA
photographer: Michael Pisarri
belly painter: Jabe Mabrey
hair: Enzo Angileri
makeup: Fabiola Arancibia
styling: Jabe Mabrey

**Stephanie Schur**
date: 8.11.14, Santa Monica, CA
photographer: Michael Pisarri
belly painter: Jabe Mabrey

**Tamera Mowry-Housley**
date: 5.26.15, Los Angeles, CA
photographer: Meiko Takechi Arquillos
belly painter: Julie Hassett
set design/props: Chloe Park
hair: Karim Odoms
makeup: Motoko Honjo

producer: Paige Dorian Productions

**Tonya Williams**
date: 6.10.15, Atlanta, GA
photographer: Gregory Miller
belly painter: Rio Sirah
set design/props: Tamara Connor
hair/makeup: Ashley Gray

**Warren Buffet**
date: 2.1.16, Omaha, NE
photographer: Gillian Zoe Segal
belly painter: Julie Hassett
styling/props: Tamara Connor
hair: Jessica Goldstein
photographer (behind the bellies):
Joshua Rosenbaum

**Willow Padilla**
date: 1.10.15, New York City, NY
photographer: Kyle Deleu
belly painter: Adam Padilla
styling: Brooke David
producer: Adam Padilla

**Zanna Roberts Rassi**
date: 3.20.14, New York City, NY
photographer: Michael Pisarri
belly painter: Jabe Mabrey
set design/props: Mural Artist—
Meres One for The Lisa Project NYC
styling: Jabe Mabrey

**Additional Support:**
Illustration: Elise Thomason
Spanx: Aubrey Whittier, Gabby Leon,
Gregg Foster, Hosong Na,
Lauren Sauer, Lisa Magazine
Post Production: Nick Leadley-VISU,
Ryan Hayslip-Slip Visual
Print Production: Melinda Scott

credits

styling: H. Audrey Boutique

**Jadideah Yarbrough**
date: 6.10.15, Atlanta, GA
photographer: Gregory Miller
belly painter: Rio Sirah
set design/props: Tamara Connor
hair/makeup: Ashley Gray
producer: Amanda Bertany

**Jellyfish: Breanna Crump,
Jane Berglund, Shavon Gihan**
date: 10.16.15, Atlanta, GA
photographer: Ryan Hayslip
belly painters: Julie Hassett and
Rio Sirah
hair/makeup: Kara Ramos, Michelle
Bergquist-Hume
styling: Brandi Barnes Shelton
producer: Amanda Bertany
videographer: Tim Redman

**Joy Cho**
date: 9.26.14, Los Angeles, CA
photographer: Stephanie Mathis
belly painter: Julie Hassett
hair/makeup: Laura Peyer

**Kate Winslet**
date: 10.9.13, Chichester, West Sussex
photographer: Michael Pisarri
belly painter: Jabe Mabrey
styling: Jabe Mabrey

**Leonor Varela**
date: 1.26.15, Los Angeles, CA
photographer: Ezra Patchett
belly painter: Julie Hassett
set design: Ariana Nakata
props: Michael Simons
hair: Marley Gonzales
makeup: Leibi Carias
styling: Annie and Hannah
producer: Paige Dorian Productions

**Lisa DeWitt-Shabsels**
date: 6.1.13, New York City, NY
photographer: Michael Pisarri
belly painter: Jabe Mabrey
styling: Jabe Mabrey

**Maggie Adams Klein**
date: 8.3.13, Atlanta, GA
photographer: Michael Pisarri
belly painter: Jabe Mabrey
styling: Jabe Mabrey

**Marcela Valladolid**
date: 3.17.15, Chula Vista, CA
photographer: Partick Hoelck
belly painter: Julie Hassett
set design/props: Ariana Nakata
hair/makeup: Lizette Prado
styling: Julie Matos Inc.
producer: Gina Leonard

**Milla Jovovich**
date: 2.24.15, Beverly Hills, CA
photographer: © Jeff Vespa
belly painter: Julie Hassett
set design/props: Ariana Nakata
hair: Kristin Heitkotter
makeup: Jillian Dempsey
styling: Julie Matos Inc.
producer: Gina Leonard

**Molly Sims**
date: 2.9.15, Beverly Hillls, CA
photographer: © Jeff Vespa
belly painter: Julie Hassett
set design/props: Kent Casey
hair/makeup: Chrissy Zogalis
styling: Bruno Lima
producer: Paige Dorian

**Morgan Miller**
date: 4.27.15, Corona del Mar, CA
photographer: Rich Wysockey
belly painter: Julie Hassett
hair/makeup: Malorie Mason
producer: Paige Dorian Productions

**Nicole Schlegel**
date: 7.13.14, Woodland Hills, CA
photographer: Michael Pisarri
belly painter: Jabe Mabrey
styling: Jabe Mabrey

**Niki Perry**
date: 10.9.13, Chichester, West Sussex
photographer: Michael Pisarri

belly painter: Jabe Mabrey
styling: Jabe Mabrey

**Noureen DeWulf**
date: 11.23.14, Los Angeles, CA
photographer: Stephanie Mathis
belly painter: Julie Hassett
set design/props: Brent Nieto
hair: Ian James
makeup: Lisa Wolf
styling: Adena Rohatiner

**Rachel P. Goldstein**
date: 7.30.14, New York City, NY
photographer: Michael Pisarri
belly painter: Jabe Mabrey

**Rachel Katz**
date: 9.17.15, New York City, NY
photographer: Kyle Deleu
belly painter: Julie Hassett
set design/props: Eyal Baruch
hair/makeup: Agata Helena
styling: Tamara Connor
child model: Ziyad Atesal

**Sally Wood**
date: 3.21.16, Miami, FL
photographer: Matt Cronin
belly painter: Ronnie Wood

**Sara Blakely**
date: 6.17.09, Atlanta, GA
photographer: Michael Pisarri
belly painter: Jabe Mabrey
styling: Jabe Mabrey

**Savannah Guthrie**
date: 7.30.14, New York City, NY
photographer: Michael Pisarri
belly painter: Jabe Mabrey
set design/props: Jabe Mabrey
hair: Mary Kahler
makeup: Laura Castrino
styling: Jabe Mabrey

**Shannon Bahrke Happe**
date: 7.18.13, Park City, Utah
photographer: Miichael Pisarri
belly painter: Jabe Mabrey

## Participants/Groups

**Alicia Roye Chestnut**
**date:** 2.3.16, Atlanta, GA
**photographer:** Ryan Hayslip
**belly painter:** Julie Hassett
**styling/props:** Tamara Connor
**hair/makeup:** Katie Eidecker
**producer:** Amanda Bertany

**Alida Boer**
**date:** 9.17.15, New York City, NY
**photographer:** Kyle Deleu
**belly painter:** Julie Hassett
**set design/props:** Eyal Baruch
**hair/makeup:** Agata Helena
**styling:** Tamara Connor
**child model:** Ziyad Atesal

**Alyssa Milano**
**date:** 8.12.14, Los Angeles, CA
**photographer:** Michael Pisarri
**belly painter:** Jabe Mabrey
**set design/props:** Katia Oloy
**hair:** Aviva Perea
**makeup:** Scott Patric
**styling:** Julie Matos

**Amanda Kim**
**date:** 8.30.13, New York City, NY
**photographer:** Michael Pisarri
**belly painter:** Jabe Mabrey

**Amanda Palmer**
**date:** 9.8.15, Summertown, TN
**photographer:** Kristin Barlowe
**hair/makeup:** Megan Thompson
**styling:** Tamara Connor

**Anna Gordon**
**date:** 10.16.15, Atlanta, GA
**photographer:** Ryan Hayslip
**belly painter:** Julie Hassett
**hair/makeup:** Kara Ramos, Michelle Bergquist-Hume
**styling:** Brandi Barnes Shelton
**producer:** Amanda Bertany
**videographer:** Tim Redman

**Anne V**
**date:** 6.5.15, San Francisco, CA
**photographer:** Thayer Allyson Gowdy
**belly painter:** Julie Hassett

**set design/props:** Karen Schaupeter
**hair:** Sydney Valentine
**makeup:** Fabiola Arancibia
**styling:** Kelly Shouey
**producer:** Karen Strauss

**Balloons: Alicia Oseikwasi-Glasford, Jasmine White, Jenae S. Chevalier, Jennifer Sabel, Lacy Coker, Michelle Rishel**
**date:** 10.15.15, Atlanta, GA
**photographer:** Gregory Miller
**belly painters:** Julie Hassett and Rio Sirah
**hair/makeup:** Kara Ramos, Michelle Bergquist-Hume
**styling:** Brandi Barnes Shelton
**producer:** Amanda Bertany
**child model:** Carina Covarrubias

**Caterpillar: Britney G. Lewis, Ewelina Zmuda Kaminski, Haydee Gamboa, Melissa Renée Laurenceau, Sasha Von Hanna, Sharron Falconer**
**date:** 10.15.15, Atlanta, GA
**photographer:** Gregory Miller
**belly painters:** Julie Hassett and Rio Sirah
**set design/props:** Ready Set Atlanta, Joe Merlucci
**hair/makeup:** Kara Ramos, Michelle Bergquist-Hume
**styling:** Brandi Barnes Shelton
**producer:** Amanda Bertany

**Catherine McCord**
**date:** 7.28.15, Los Angeles, CA
**photographer:** Ezra Patchett
**belly painter:** Julie Hassett
**set design/props:** Heidi Seidell
**hair:** Leah Dempsey
**makeup:** Lisa Dempsey

**Coco Rocha**
**date:** 2.27.15, New York City, NY
**photographer:** Blaise Hayward
**belly painter:** Julie Hassett
**set design/props:** Eyal Baruch
**hair:** David Cruz
**makeup:** Christopher Ardoff
**styling:** Taryn Shumway

**producers:** Karen Strauss, Gina Leonard
**illustrator:** Elise Thomason

**Elizabeth Chambers**
**date:** 10.16.14, Los Angeles, CA
**photographer:** Stephanie Mathis
**belly painter:** Julie Hassett
**hair:** Kristin Heitkotter
**makeup:** Carissa Ferreri

**Elsa Pataky**
**date:** 3.4.14, Malibu, CA
**photographer:** Michael Pisarri
**belly painter:** Jabe Mabrey
**hair/makeup:** Kindra Mann
**styling:** Jabe Mabrey

**Erin Burnett**
**date:** 8.24.15, Brielle, NJ
**photographer:** Blaise Hayward
**set design/props:** Eyal Baruch
**hair:** Shpresa Neziri
**makeup:** Nancy McNamara

**Gillian Hearst Simonds**
**date:** 6.26.14, New York City, NY
**photographer:** Michael Pisarri
**belly painter:** Jabe Mabrey
**hair/makeup:** Jasen Kaplan
**styling:** Jabe Mabrey

**Heather Mycoskie**
**date:** 11.19.14, Los Angeles, CA
**photographer:** Stephanie Mathis
**belly painter:** Julie Hassett
**set design/props:** Brent Nieto
**hair:** Taylor Stevenson
**makeup:** Carissa Ferreri

**Holly Branson**
**date:** 11.17.14, London, UK
**photographer:** Rupert Peace
**belly painter:** Julie Hassett
**hair/makeup:** Ginni Bogado
**styling:** Phoebe Roche

**Holly Williams**
**date:** 9.12.14, Nashville, TN
**photographer:** Kristin Barlowe
**belly painter:** Julie Hassett

**Sara Blakely**
CREATIVE DIRECTOR

**Chelsea McMillan**
PRODUCER

**Lea Friedman**
DESIGNER

**Juliet D'Ambrosio**
WRITER

**The Belly Art Project** started as one of my fun, crazy, personal ideas, and it quickly grew into something much bigger (pun intended!). Bringing this book to life has been a true labor of love, and it simply wouldn't have been possible without the skills, talents, time—and bellies—of so many amazing people. I want to give a special thanks to the photographers, belly painters, and Chelsea McMillan, who as producer wore a million hats, kept all the balls in the air, and is probably a world authority on pregnancy by now! I'm thrilled to be part of a group so inspired to do their part to help moms in need. Thank you, thank you, everyone!

xo,
Sara Blakely

Add your #bellyartproject photo here!

EVERY
BELLY
IS
BEAUTIFUL.

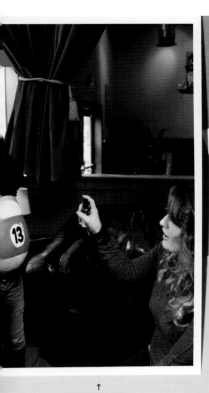

↑
Tip: Spray your creation with nontoxic fixative so the paint stays looking fresh.

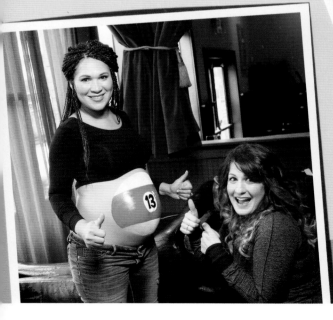

*continued:*

## Step 4
## Protect yourself

Tuck some paper towels in your waist(ha!)band or under your shirt/bra to protect your clothing. Best to already be dressed for your photo before you begin painting.

## Step 5
## Paint!

Play some music, get comfortable and let the creativity flow. Keep wipes on hand to clean your smudges. And be sure to get all around the belly (which is where a friend comes in really handy). Babies often love this part—expect to feel some kicks and wiggles!

## Step 6
## Pic + Post

Grab colorful props and snap away, or head to a cool location for your belly pic. Play around with different camera angles and lighting to get the most from the environment. Then post and tag #bellyartproject, and watch the likes roll in. And help us spread the word!

### Extra Tips

Belly painting makes an excellent baby shower activity, and the photos help the memories last forever.

Consider including your partner, pets, kids and friends in the process and in the pics. The more the merrier!

Sponge on the paint for a softer effect.

Practice your painting on a balloon. We did!

Pick colors that contrast your complexion (light colors on darker skin tones, dark and bright colors on lighter skin tones).

Add body glitter before the paint dries for extra sparkle.

Totally optional, but if you use a barrier spray before you start painting it helps the removal process.

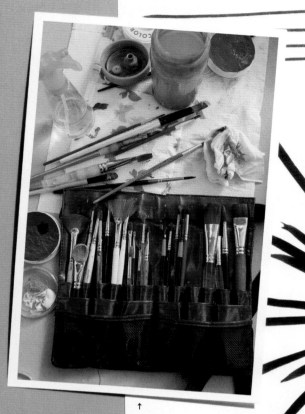

↑
Tip: Soft, synthetic brushes work best—rounded ones for the bigger strokes, smaller ones for details.

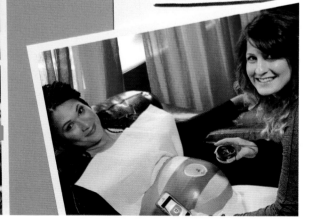

## How to Paint a Belly

It's easy to transform your belly into a work of art. All you need are a few simple supplies, a partner to help paint or take pics, and a sense of humor— the process is as much fun as the finished product!

Here's a quick and simple breakdown of the steps, and tons of great tips to help get you started unleashing your own belly creativity.

### Step 1
### Brainstorm an amazing/fun/beautiful/ hilarious/cute idea

The best #bellyartproject pics are the ones that capture who you are and what you love to do. Round objects give your belly a chance to "become the object" and trick the eye. Other ideas are: sayings, words, faces, images. Have fun!

### Step 2
### Practice!

It's easier to work through an idea on paper first, so draw some belly-shaped ovals, and develop your sketches on them. To play with dimension you can practice on a balloon. And remember, you're not shooting for perfection—just something perfect for you!

### Step 3
### Supplies

You'll be able to find everything you need at your favorite craft store and drugstore.

Baby wipes (use 'em now to clean mistakes and save the rest—they'll come in handy in a few months!)
Spray bottle of water
Non-toxic, water-based paint
Brushes
Sponges
Paper towel
White and black eyeliner
Barrier spray (optional)
Finishing spray (optional)

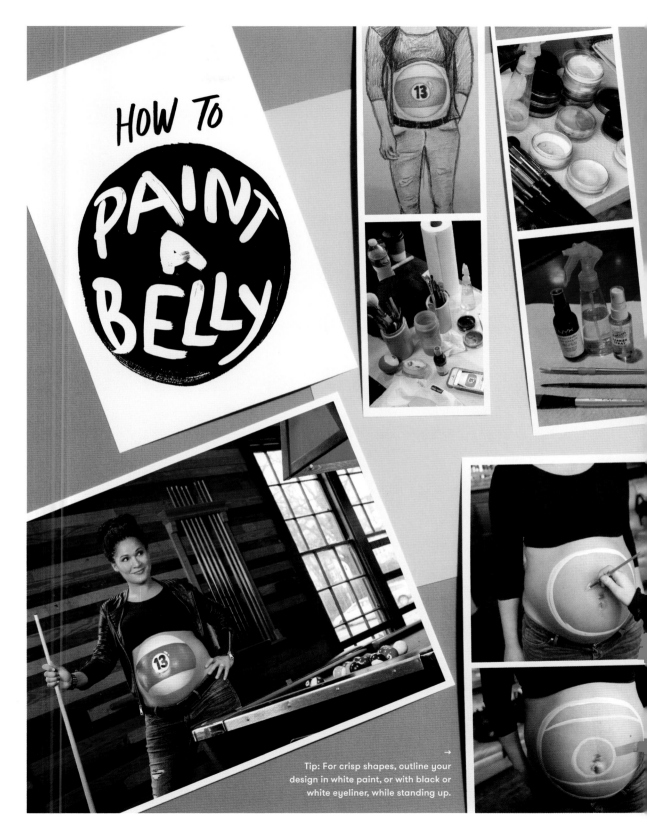

# HOW TO PAINT A BELLY

Tip: For crisp shapes, outline your design in white paint, or with black or white eyeliner, while standing up.

You just have to roll with it!"
—**Leonor Varela**

"At first, all my husband and I did was talk about the pregnancy and the baby. It's so exciting it's hard not to get obsessed. But you've got to make an effort to spend some time focusing and connecting to each other—even if it's just discussing a book or a movie. The relationship with your partner on the journey is so important!"
—**Gillian Hearst Simonds**

"For the first three months, I was hungry like a truck driver! Carbs, carbs, carbs. After that, especially in the third trimester, I've actually wanted to eat but don't really have the room. I'm packed full of baby!"
—**Leonor Varela**

"Motherhood is the hardest job. Think three AM feedings, or when you're rushing to get out the door and the baby spits up in your hair and poops through yet another diaper! But it's also miraculous, and you just love your tiny human more every day."
—**Nicole Schlegel**

"I'll be honest: Watching my body change so much scared me to death at first! But then I realized that I'm designed for this, and that my body knows exactly what to do."
—**Stephanie Schur**

"I can have dessert every day and not blink an eye! Bring it on! (Of course, I make sure to eat my fruits and veggies, too …)"
—**Catherine McCord**

"It's really pretty funny: Sometimes my husband and I just watch my tummy wiggle and think, 'This is like a science experiment!' And the cravings…I've literally been dreaming about fried dough. It's this beautiful, tough, crazy, awkward, gorgeous experience—it's just amazing."

**—Milla Jovovich**

"I'm here to tell you, pregnancy brain is real! And the closer you get to full term, the worse it gets. It's like I'm in a little fog, and sometimes I open my mouth and can't believe what comes out!"

**—Anne V**

"Fertility issues and treatments are so common, and yet still a taboo issue. It's the most difficult thing I've been through. My best advice would be to find friends who have been through it and other women. Persist. You will get there."

**—Zanna Roberts Rassi**

"Some women work. Some don't. Some women have money. Some don't. Some women have families. Some don't. But no matter what, we're all in this together. You gotta have your village!"

**—Molly Sims**

"Being pregnant and having a baby is the most monumental and celebrated time in a woman's life. It can also be overwhelming trying to consider every choice you make, knowing there is a little person taking a piece of everything you devour—but you can never go wrong with avocado!"

**—Stacy Keibler**

"Burps, burps, more burps. So my husband says, 'You're a frog now,' which is kind of true.

← *Helping moms in Haiti*

↑
**Haiti**
In September 2014, Sara Blakely joined Christy Turlington Burns and the Every Mother Counts staff in Haiti. During her trip, she visited hospitals and met midwife trainees, getting to see first-hand the invaluable work EMC is doing to make childbirth safe for all women.

# HAITI + EMC

*Photobomb!*

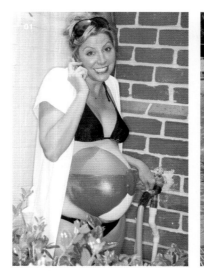

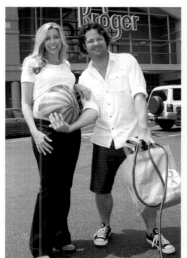

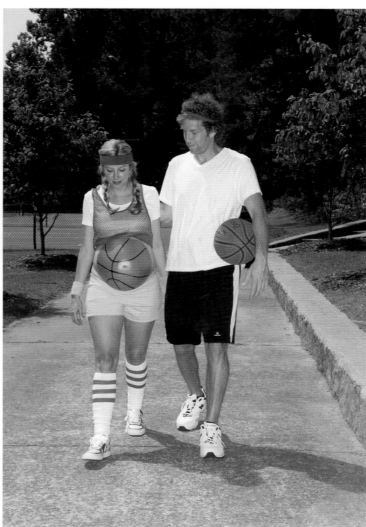

↑
Sara Blakely
After the pool shoot Sara decided to water her flowers ... nesting until the bitter end.

To photograph the watermelon, we showed up at a local grocery store in the middle of a busy, regular day. The other shoppers were a little confused at first when Sara plopped her belly right near the melons, but then they thought it was hilarious. We were in and out in less than 20 minutes!

Sara and her husband, Jesse
Enjoying the moment three days before they welcome their first son.
→

01 **Sara Blakely**_6.17.09_Atlanta, GA

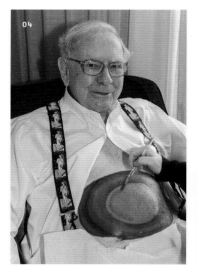

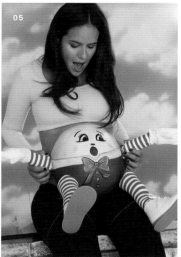

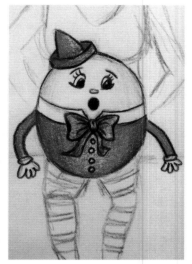

↑

Rachel Katz

Humpty Dumpty was so cute but was a really tricky belly to photograph! Even with fishing wire and belly glue we had a very hard time keeping him together. The shoot was just like the nursery rhyme, "All the king's horses and all the king's men couldn't put Humpty together again!"

←

Warren Buffett

Warren is an amazing man, with an incredible sense of humor. We are so grateful to have him in *The Belly Art Project* book. The fact that he donated his time for the photo shoot and let us actually paint on his belly for a good cause is just another example of his generous spirit.

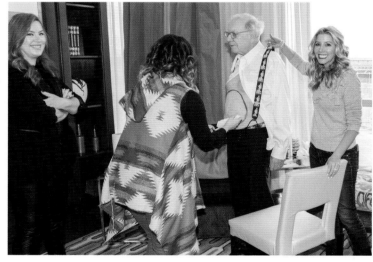

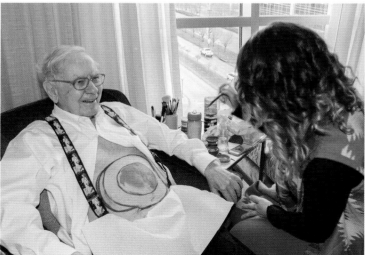

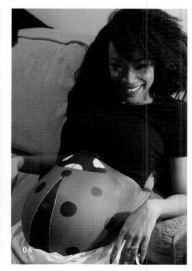

04 **Warren Buffet**_2.1.16_Omaha, NE   05 **Rachel Katz**_9.17.15_New York City, NY
06 **Sonequa Martin-Green**_12.1.14_Los Angeles, CA

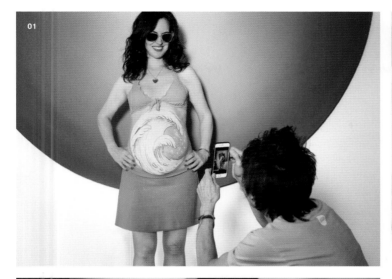

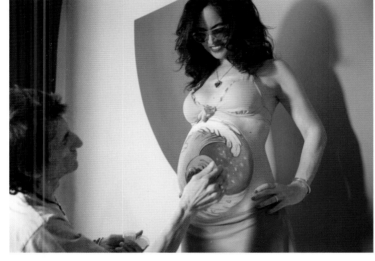

← Sally Wood
We were lucky to catch Sally and Ronnie in Miami while he was touring with The Rolling Stones. The shoot didn't have much time for planning but luckily Ronnie is an artist as well as a musician. The couple concepted the belly art—perfect for the location!—and Ronnie painted Sally's belly. They're expecting twin girls! The tour photographer took the shot.

*← chill time!*

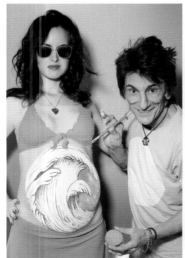

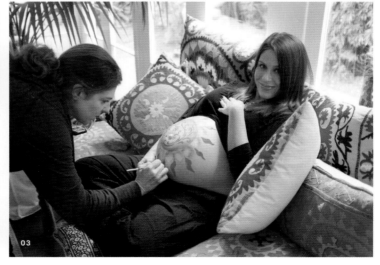

01 **Sally and Ronnie Wood**_3.21.16_Miami, FL   02 **Nicole Schlegel**_7.13.14_Woodland Hills, CA
03 **Soleil Moon Frye**_2.6.14_Los Angeles, CA

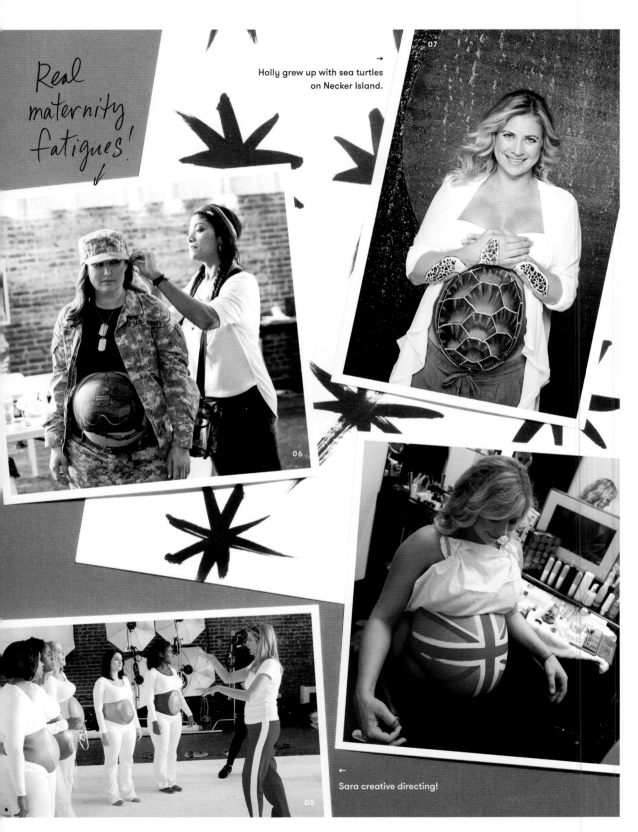

Real maternity fatigues!

Holly grew up with sea turtles on Necker Island.

Sara creative directing!

05 **Balloons Shoot**_10.15.15_Atlanta, GA  06 **Anna Gordon**_10.16.15_Atlanta, GA  07 **Holly Branson**_11.17.14_London, UK

*Photobomb!*

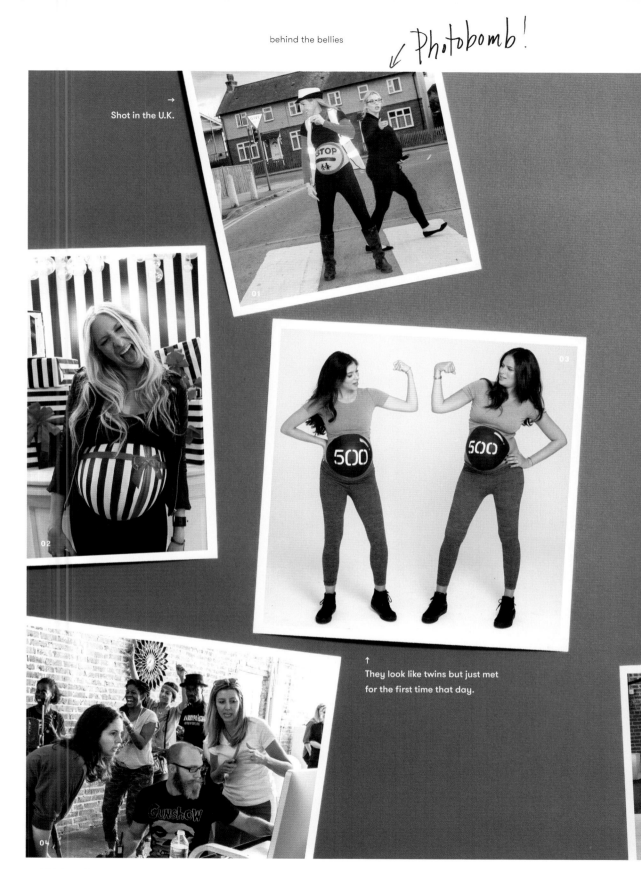

Shot in the U.K.

They look like twins but just met
for the first time that day.

01 **Niki Perry/Kate Winslet**_10.9.13_Chichester, West Sussex   02 **Holly Williams**_9.12.14_Nashville, TN
03 **Alida Boer/Rachel Katz**_9.17.15_New York City, NY   04 **Balloons/Caterpillar Shoot**_10.15.15_Atlanta, GA

anything you don't really want to do. It's like the world's best doctor's note!"

—Noureen DeWulf

"It's amazing to me that during your pregnancy you go about your business and while you're eating, sleeping and working this tiny person is just forming into existence. You don't have to think to yourself in the morning, 'Ok, today I have to build this baby's heart. Oh and let's create some ears.' It's amazing how your body does such beautiful work while you're simply brushing your teeth!"

—Coco Rocha

"It's a ton of work, but the best work I've ever wanted to do! My whole perspective on life as I knew it changed as I had someone else to be breathing for, eating for, loving for, and protecting with my

every thought and action. The feeling is so magical."

—Rachel P. Goldstein

"I come from Russia, and I've traveled the world, so I've seen that there are so many places where women can't get incredibly basic care. We are so lucky, and it's amazing to be able to show how grateful we are for the love and opportunities we have by supporting women everywhere. Mothers bring life. I'm proud to be one!"

—Anne V

"Life begins with motherhood. I really believe that—like, I feel like not only are we creating life, but this is where a whole new chapter of my life begins. It's thrilling!"

—Willow Padilla

"At the ultrasound when I found out I was having two girls, I turned to my husband and said, 'Two words: Wardrobe. Budget.'"

—Zanna Roberts Rassi

"There's so much chaos going on in everyone's daily lives, but pregnancy forces you to relax and take a breather. Everything takes more time, your body and brain move a little slower, but it's actually amazing. It's like your own built-in retreat."
—Amanda Palmer

"I didn't have the ice cream and pickles cravings. Instead, I wanted Snickers®, Skittles®, and ravioli— yep, good ol' Chef Boyardee®!"
—Sonequa Martin-Green

"I love the way people are extra nice towards you when you're pregnant— even strangers! They give you that look of approval when they pass you on the street. They open doors, offer to carry your luggage. But the minute the baby pops out, boom! You're back to being a regular person in their eyes. Ha!"
—Joy Cho

"When I got pregnant, I sometimes got scared and started to

think, 'Oh my God, my butt will never look the same, and my boobs are going to be flour sacks down to my belly button!' But at the end of the day, it's not that bad, and of course you end up with an amazing little miracle. So it's totally worth it!"
—Holly Williams

"Mothers supporting other mothers is the best! It's love leaning in instead of leaning out. It's so important—for us, and to teach our young girls to give back and to support each other too."
—Molly Sims

"I hate to admit it, but the best part of being pregnant I think is that you have an excuse to get out of

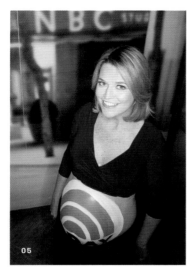

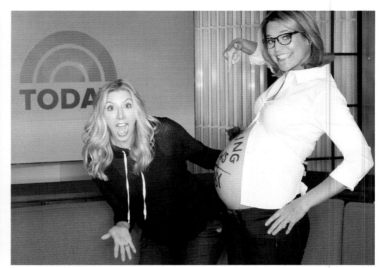

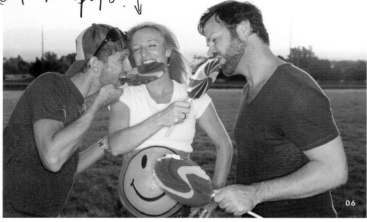

Real lollipops! ↓

↑
Savannah Guthrie
Savannah's shoot was tricky, since we only had three hours to set up, paint and photograph Savannah immediately after the TODAY show wrapped—not a lot of time to accomplish three different looks! It was a total blast doing it all on the TODAY set, and Savannah was a great sport about it all—even when the lollipop took forever to paint!

Willow Padilla
Willow's husband, artist Adam Padilla, painted the pineapple on her belly.
↓

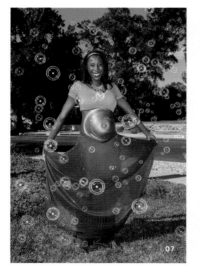

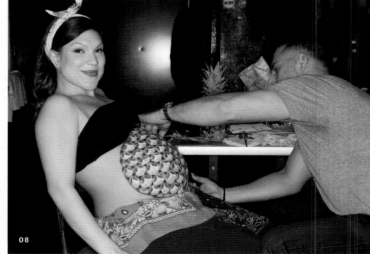

05 **Savannah Guthrie**_7.30.14_New York City, NY   06 **Shannon Bahrke Happe**_7.18.13_Park City, Utah
07 **Nicole Schlegel**_7.13.14_Woodland Hills, CA   08 **Willow Padilla**_1.10.15_New York City, NY

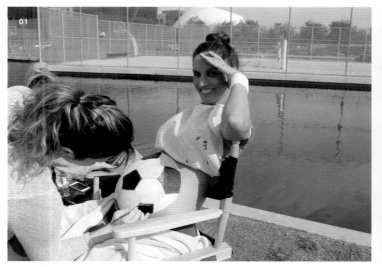

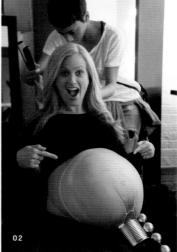

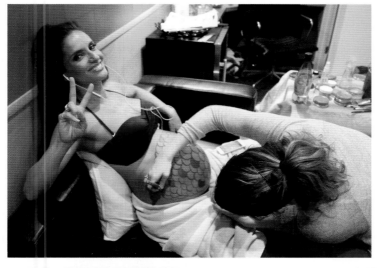

↑
Jadideah Yarbrough
Jadideah was Spanx's first employee, and she's been with Sara and the company ever since.

Belly Quotes
We shot this at Big Studios in Atlanta—and, like all our other shoots, made sure there were tons of healthy snacks for pregnant mamas!
↓

Nom-Nom

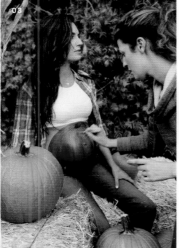

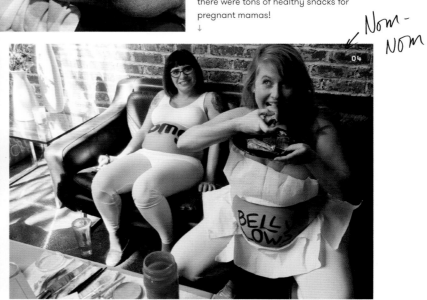

01 **Leonor Varela**_1.26.15_Los Angeles, CA   02 **Jadideah Yarbrough**_6.10.15_Atlanta, GA   03 **Elizabeth Chambers**_10.16.14 _Los Angeles, CA   04 **Sasha Von Hanna/Melissa Renée Laurenceau**_10.15.15_Atlanta, GA

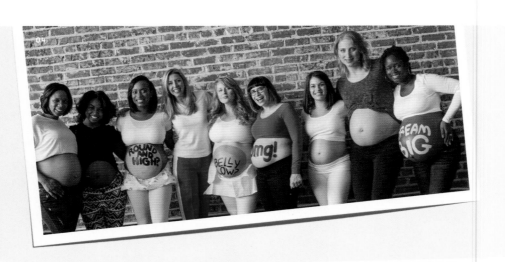

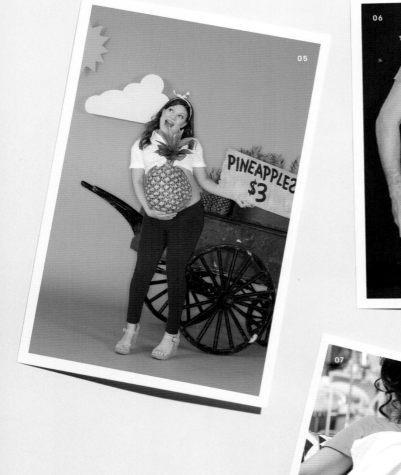

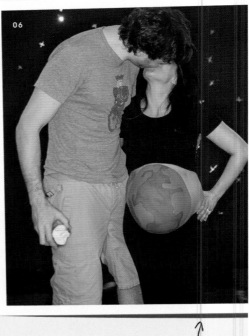

Hubs on set!

04 **Balloons/Caterpillar Shoot**_10.15.15_Atlanta, GA  05 **Willow Padilla**_1.10.15_New York City, NY
06 **Lisa Dewitt-Shabsels**_6.1.13_New York City, NY  07 **Joy Cho**_9.26.14_Los Angeles, CA

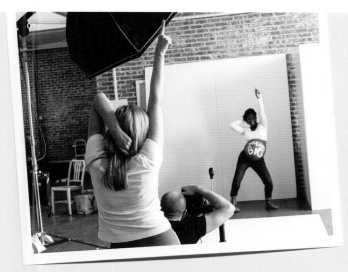

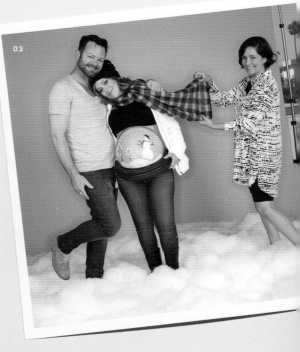

This Winter Wonderland scene was shot on a hot and sunny August day in LA. Two people (including Belly Art Project producer Chelsea McMillan!) stood on ladders, throwing fake snow down while an assistant held Alyssa's scarf in place to achieve the windblown look.
→

Chelsea, Sara's childhood friend, who helped make this book happen.
↓

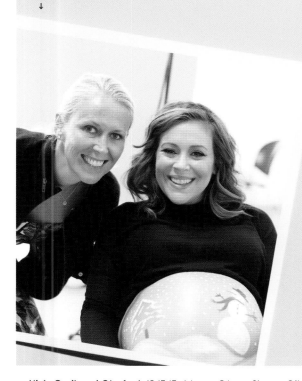

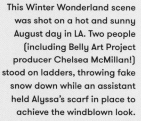

01 **Alicia Oseikwasi-Glasford**_10.15.15_Atlanta, GA  02 **Shavon Gihan/Jane Berglund**_10.16.15_Atlanta, GA
03 **Alyssa Milano**_8.12.14_Los Angeles, CA

"Being pregnant inspired me to look at my past, present and future with fresh eyes and a new outlook."

**—Stacy Keibler**

"The best advice I was given for this pregnancy was, 'Don't listen to any-one's advice!' I loved it! Just be you, trust your instincts, and that you probably know what's best for you. You've got this!"

**—Coco Rocha**

"Pregnancy brain has gotten me in trouble— like dropping my purse in the middle of the a busy intersection, and not even realizing it! I just kept walking on my merry way…."

**—Tonya Williams**

"Pregnancy and moth-erhood have helped grow the concept of love and the reality of love for me. I feel like I've been enlightened in that way—the love has literally expanded to be endless, as big as the universe. It's a beautiful thing."

**—Sonequa Martin-Green**

"I really think it's up to mothers to change the world for each other. To use our compassion and strength to make a healthier, safer, better world for women and girls everywhere. After all, we are the stronger gender!"

**—Alyssa Milano**

"It's easy to forget, but men get totally into this too. I walked in on my husband and a bunch of his buds swapping their wives' pregnancy stories— it was so cute!"

**—Nicole Schlegel**

"I never thought I'd say this, but I love having people touch my belly. Some people get really weirded out, but I'm like 'no really—come and touch! There's a little person in there!'"

**—Marcela Valladolid**

"I'll hold up a little sweater that somebody gave us, and my husband literally bursts into tears! You'd think that clothes wouldn't be the thing that translates for guys, but clothes have made it really real for him. He gets weepy over little socks!"

**—Elizabeth Chambers**

"I make some of the less fun parts into sort of a game. Like, how many times can I get up to pee in one night? Can I beat my record from last week? How many shoe sizes will my feet swell?"

**—Noureen DeWulf**

"It's hard in our society, but as your body changes you have to keep telling yourself that you are a beautiful, natural, healthy woman. And celebrate the fact that your profile looks different than usual, but that different can be so beautiful!"

**—Willow Padilla**

"Everywhere in the world, a mom is a mom. We're so much more alike than we are different. We get pregnant, give birth, raise a newborn, raise a toddler, raise a person. No boundary on earth can stop us from supporting each other!"

**—Tamera Mowry-Housley**

*Elsa is expecting twins*

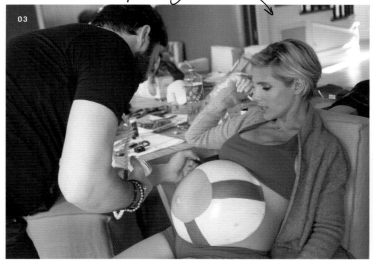

**Zanna Roberts Rassi**
Pregnant with twins and still rocking it!
We shot this at Zanna's husband's well-
known fashion-photo studios MILK in NYC.
Oh, if these walls could talk....

**Erin Burnett**
Our original concept was to shoot inter-
national reporter Erin's belly painted as
a globe, but since the baby arrived a few
days early, that clearly didn't happen!
We used the globe as a prop, and shot
her and baby Colby in this gorgeous
natural light in Erin and her husband's
lake house near the Jersey Shore.
↓

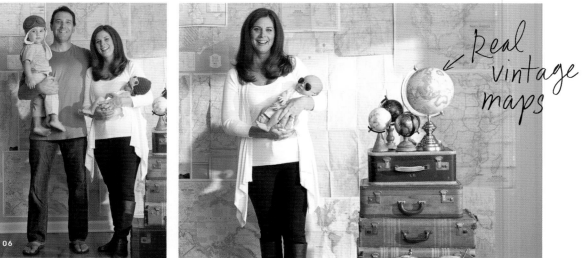

*Real vintage maps*

03 **Elsa Pataky**_3.4.14_Malibu, CA   04 **Jasmine White**_10.15.15_Atlanta, GA
05 **Zanna Roberts Rassi**_3.20.14_New York City, NY   06 **Erin Burnett**_8.24.15_Brielle, NJ

Makeup artist for hire!

 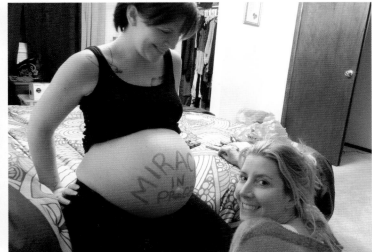

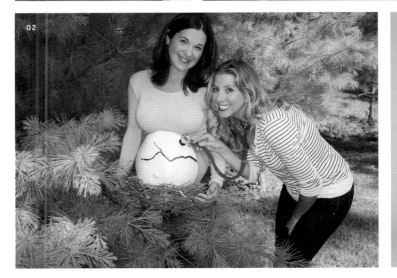 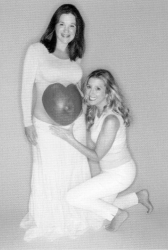

01 **Michelle Remmey**_4.14.14_Etters, PA   02 **Michelle Zastrow**_7.5.14_Milwaukee, WI

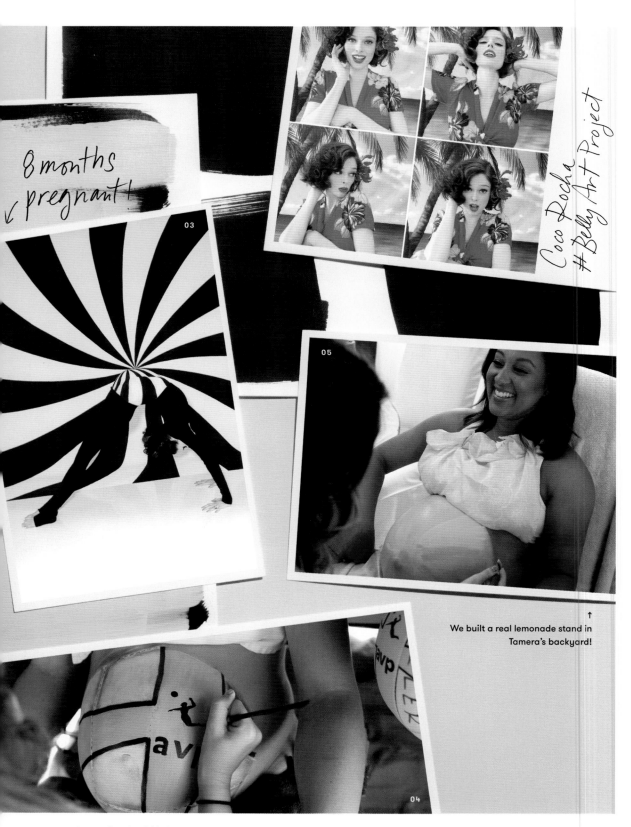

8 months pregnant!

Coco Rocha #Belly Art Project

We built a real lemonade stand in Tamera's backyard!

03 **Stacey Bendet**_7.23.15_New York City, NY    04 **Morgan Miller**_4.27.15_Corona Del Mar, CA
05 **Tamera Mowry-Housley**_5.26.15_Los Angeles, CA

Stacey Bendet is a creative force. The Op-Art look was her idea, and during photoshoot downtime, she blew our minds with yoga moves—including full-on backbends!

→

↑
We hand-taped 1,268 mini-mirrors on Amanda's belly. We shot this at The Farm, a beautiful and rustic retreat in Tennessee, where Amanda had gone to give birth in their Midwifery Center.

*It takes a village...*

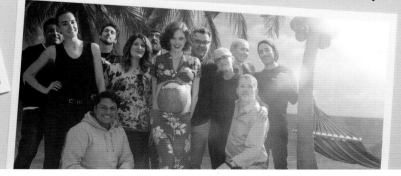

01 **Amanda Palmer**_9.8.15_Summertown, TN   02 **Coco Rocha**_2.27.15_New York City, NY

everybody's number one priority. Of course, I'm a little biased…."

—Milla Jovovich

"Someone said to me that after your first child you mourn the life you had, but welcome the new life you have. I'm so grateful for those words of wisdom."

—Jadideah Yarbrough

"Pregnancy really makes me feel closer to other women than ever before. All mothers have experienced the same essential thing. It's like we all share this magical secret. It's a real sisterhood."

—Elizabeth Chambers

"It's so crazy that you can go literally months without ever seeing your feet!"

—Haydee Gamboa

"I've had friends who tell me 'I love being pregnant—it's all so amazing!' and I'm thinking 'What are you smoking, lady? And can I have some?!' Of course I love the opportunity to bring new life into the world. But the truth is, baking the baby can also be really hard!"

—Morgan Miller

"Why does everyone say pregnancy is nine months? 40 weeks is 10 months! Ten loooonnnng months. It can be tough, and everyone has their moments. But I've also never felt so lucky in my life!"

—Savannah Guthrie

"If people offer to help, let them. It really does take a village!"

—Willow Padilla

"During dinner the other night, my three-year-old pointed at my belly and asked, 'So who's that baby's daddy?' I responded, 'Well, this baby has the same daddy as you!' And she looked at me like I was crazy and said, 'No, Mommy. That baby's daddy is a potato.'"

**—Joy Cho**

"It took me three years to get pregnant and stay pregnant. I now realize and appreciate it for the miracle it is. Every time I feel the babies move, it's mind-boggling and amazing!"

**—Zanna Roberts Rassi**

"I always thought that I would teach my children so many lessons in life. Instead they are my greatest teachers."

**—Soleil Moon Frye**

"Listen, I have fat in places I never thought could get fat!

And you walk around with your insides just all smooshed. But you just have to laugh, embrace it and love it. It's your journey and you're creating a human being—how badass is that?"

**—Tamera Mowry-Housley**

"Picking a name for another human being is crazy! My husband actually put together a PowerPoint presentation during my first pregnancy with five first names, five middle names, and our last name. I'm like, 'You have lost your mind….'"

**—Molly Sims**

"Mothers are giving birth to the next generation. They're superhuman! Respecting women and supporting mothers should be

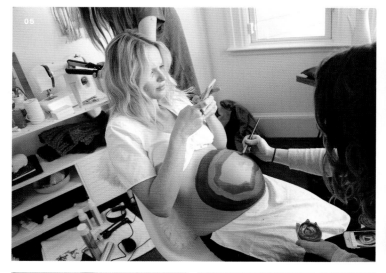

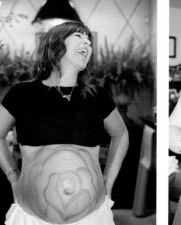

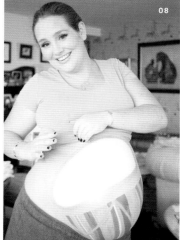

↑
Amanda Kim
Sara met Amanda at the nail salon.
So cute, and so happy she said yes!

←
Gillian Hearst Simonds
Gillian's husband loves playing
bongo drums!

Tonya Williams
We hand-molded and painted the
ceramic props to give the piggy bank
belly an authentic look.
↓

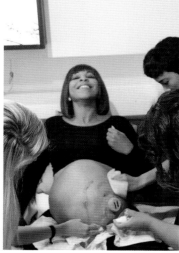

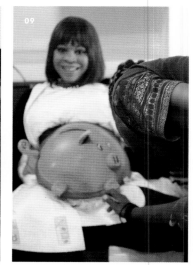

*Mom-in-law* ↘        *Mom* ↘

↑
Catherine McCord
Catherine craved olives throughout her entire pregnancy. And they're also her daughter's fave food!

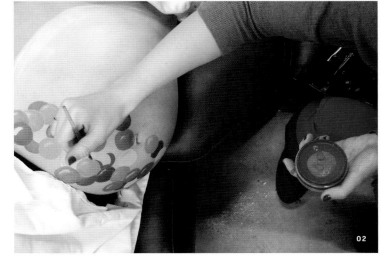

Heather Mycoskie
This sweet kitty's name is Graham.
↓

01 **Catherine McCord**_7.28.15_Los Angeles, CA   02 **Molly Sims**_2.9.15_Beverly Hills, CA
03 **Heather Mycoskie**_11.19.14_Los Angeles, CA   04 **Marcela Valladolid**_3.17.15_Chula Vista, CA

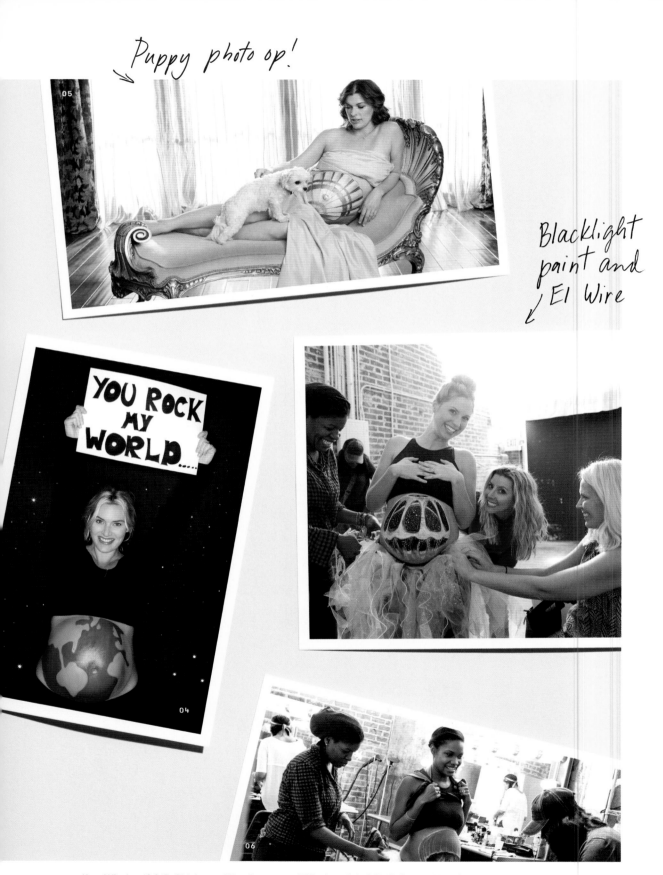

Puppy photo op!

Blacklight paint and El Wire

YOU ROCK MY WORLD.....

04 **Kate Winslet**_10.9.13_Chichester, West Sussex    05 **Milla Jovovich**_2.24.15_Beverly Hills, CA
06 **Shavon Gihan**_10.16.15_Atlanta, GA

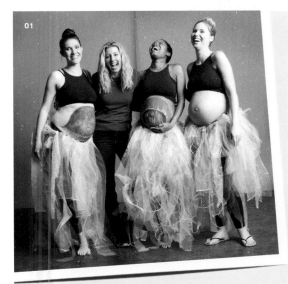

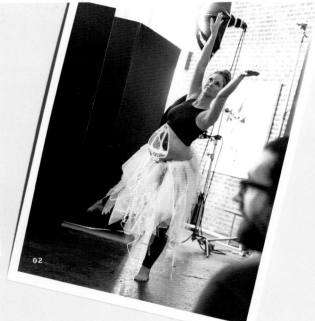

Kate insisted on making sure the UK was well represented on her Earth belly!
→

The Alice in Wonderland scene was shot in the photographer's San Francisco backyard. Anne loves children's books, which inspired our Alice theme!
↓

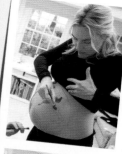

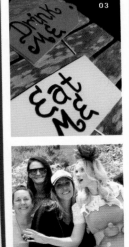

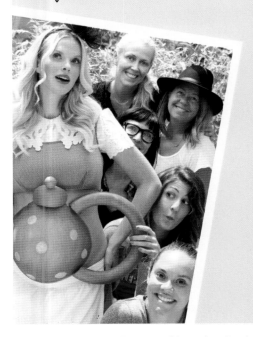

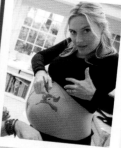

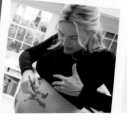

01 **Jellyfish Shoot**_10.16.15_Atlanta, GA  02 **Jane Berglund**_10.16.15_Atlanta, GA  03 **Anne V**_6.5.15_San Francisco, CA

On location
in England

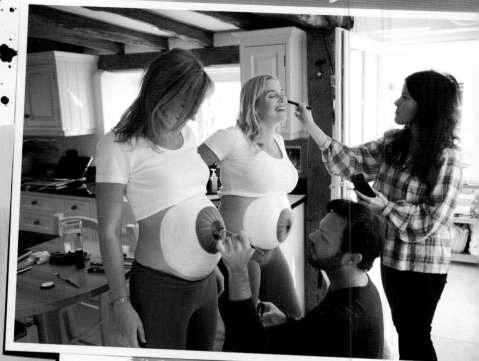

Crew ate 47
donuts in 5 hours!

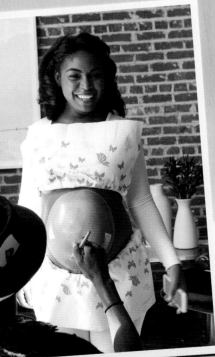

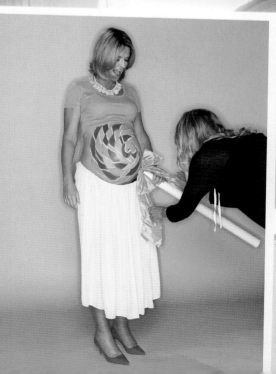

♡ your
stylist!

BEHIND
the
BELLIES →

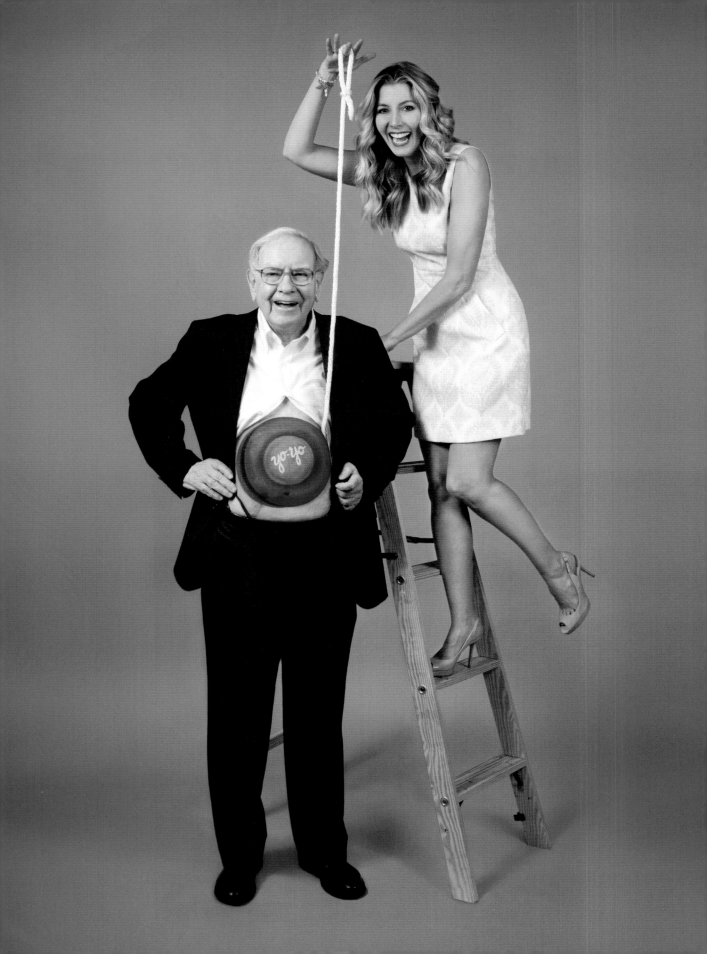

INVESTMENTS

GO↑UP

AND↓DOWN

Supporting moms
always goes up!

**THE YO-YO**

Warren Buffett • Sara Blakely

Great question!

Here's how it all begins: Sara is lucky enough to sit next to Warren at a lunch. When he asks her what she's been up to, she pulls out her iPhone and shows him pictures of The Belly Art Project. He laughs hysterically, loves the idea, and immediately says, "I want to be in the book!" Sara responds, "But you're not pregnant!" He grabs his belly and says, "Are you telling me you don't have enough here to work with?"

Fast-forward a year: Sara wonders … was Warren really serious? Would he really be that brave, daring, and awesome?

She emails him, and sends a list of the few remaining round objects left on the planet that haven't already been painted on bellies. Warren's email back … "Count me IN! With my belly, we should consider reproducing the entire U.S. Constitution … but I'll take the yo-yo."

A week later, Sara and the team head to Omaha for the once-in-a-lifetime experience of painting a yo-yo on Warren Buffett's belly.

**On behalf of moms everywhere, thank you Warren!**

How does
Warren Buffett
end up in a belly book
FULL OF pregnant
WOMEN?

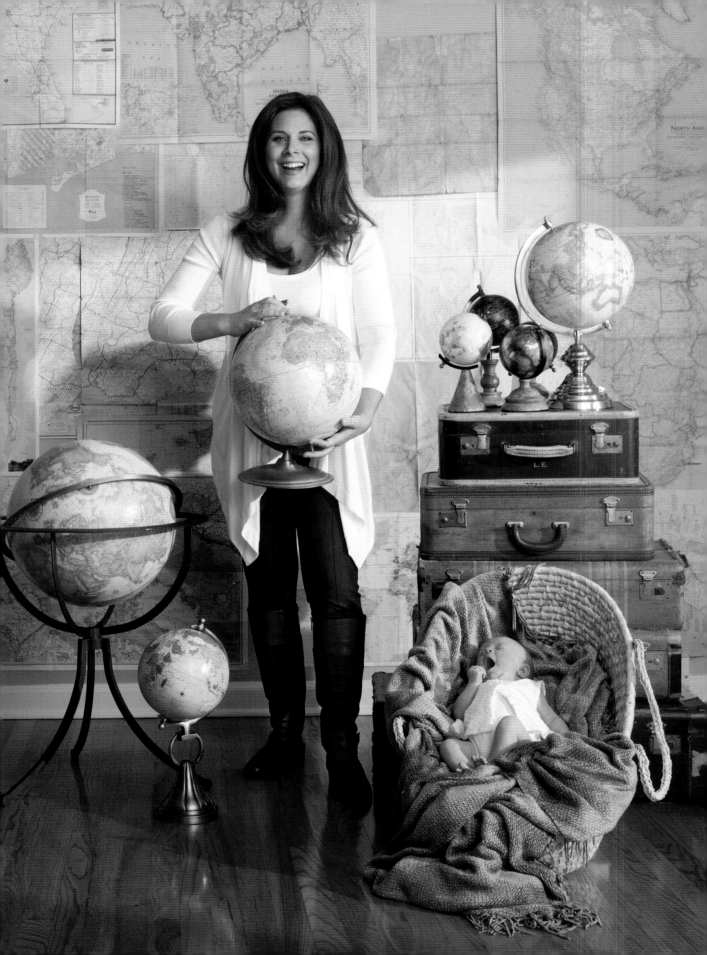

Arriving July 26 ~~18~~ 

OOPS!

THE GLOBE

**Erin Burnett** • CNN News Anchor

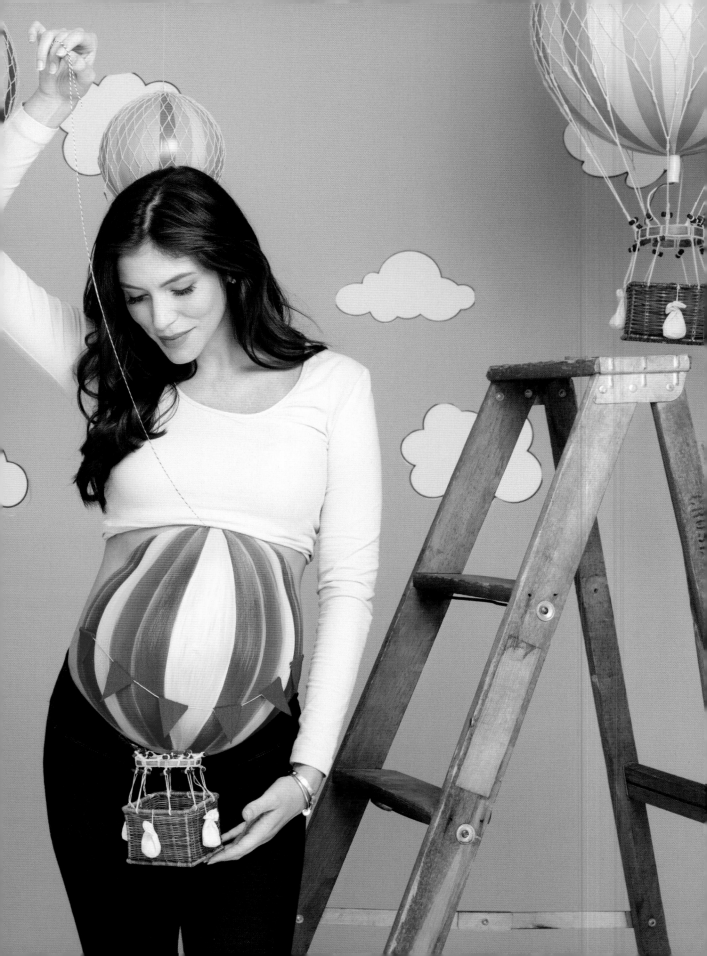

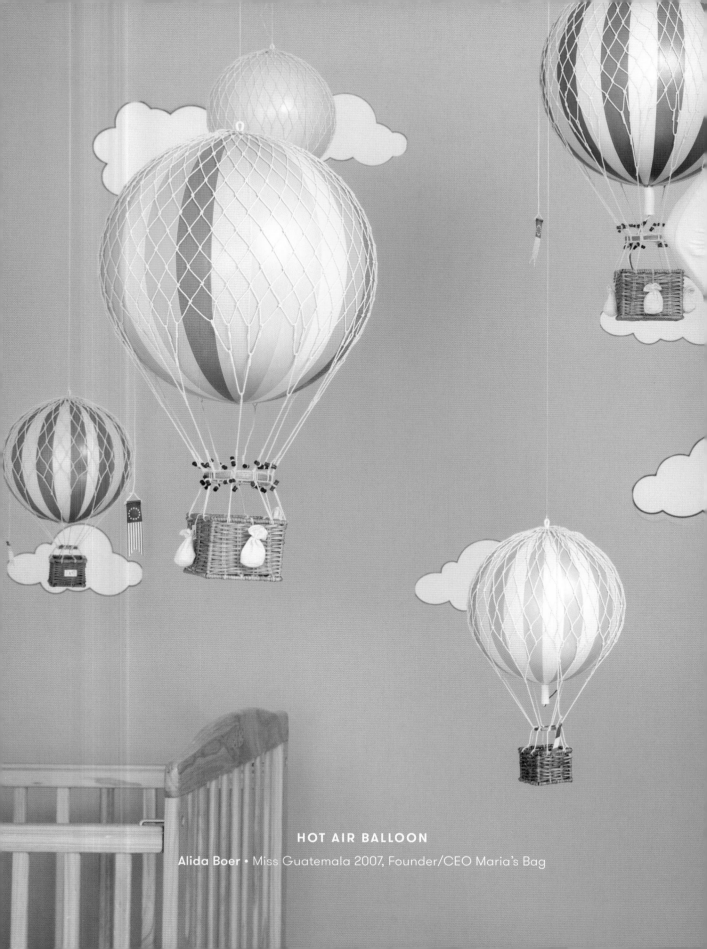

## HOT AIR BALLOON

**Alida Boer** • Miss Guatemala 2007, Founder/CEO Maria's Bag

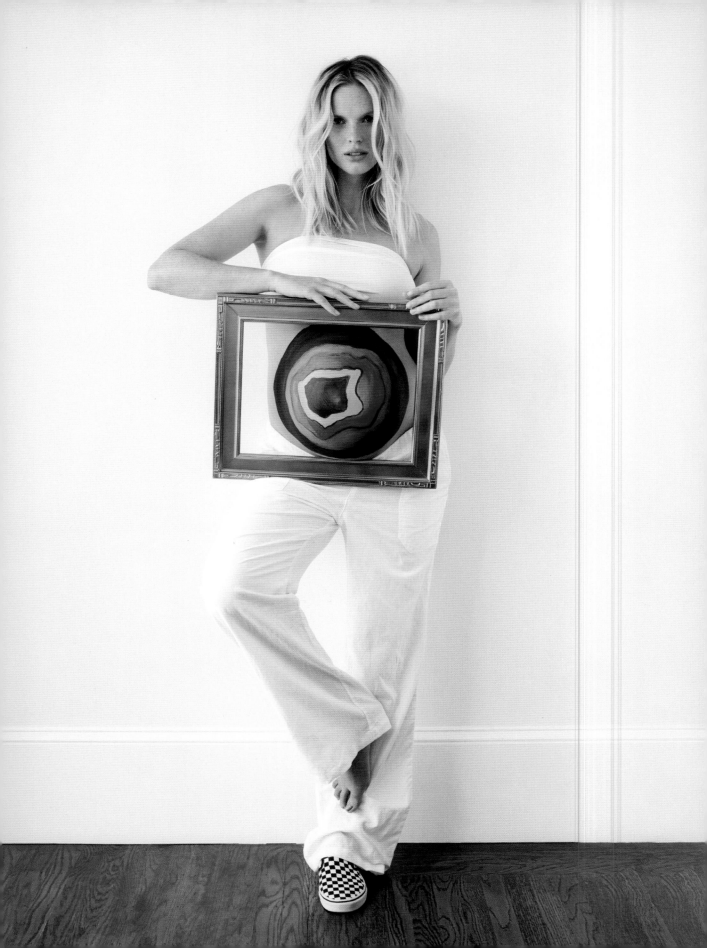

*celebrate*
*imperfect !*

*it's all*
**beautiful.**

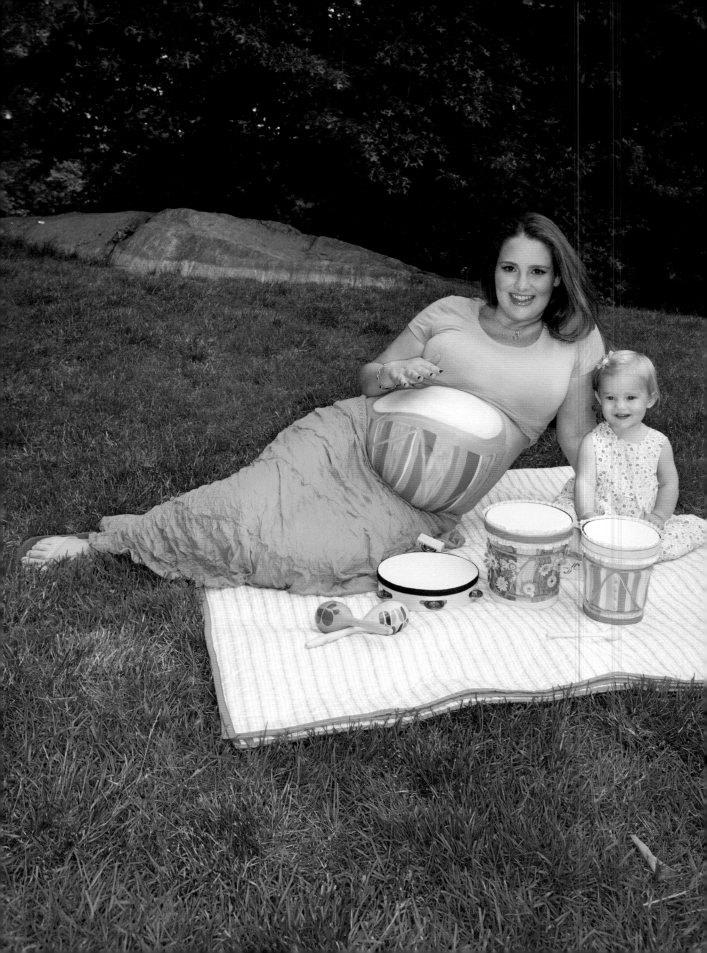

*Moms grow future Moms*

**BONGO DRUM**

**Gillian Hearst Simonds** • Contributing Editor, *Town & Country*

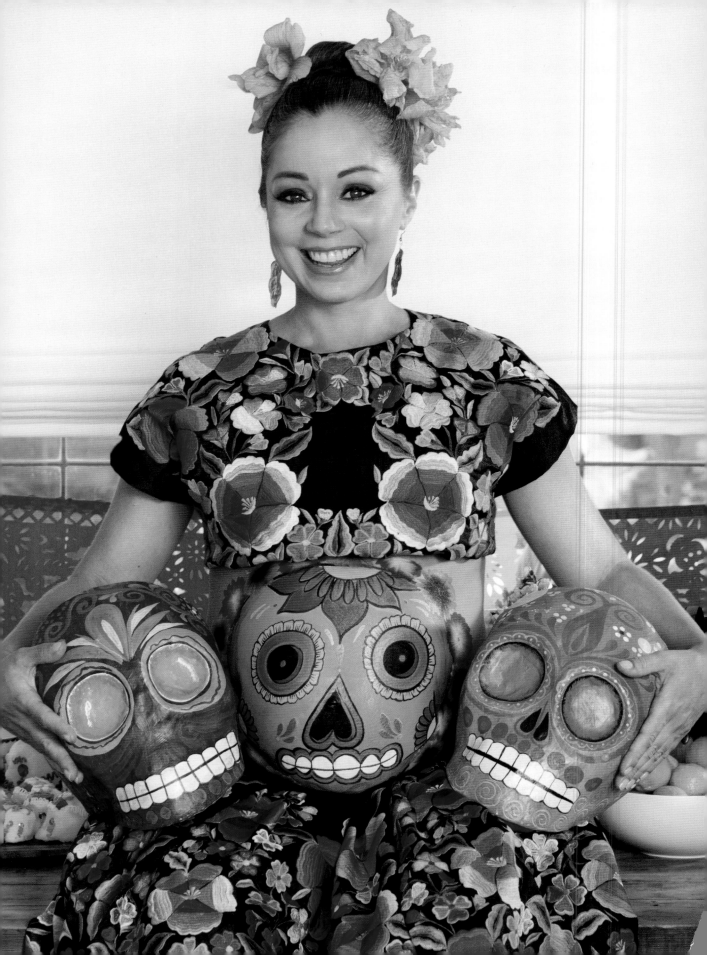

WHEREVER
YOU'RE FROM,

# DO YOUR
# OWN
# BELLY
# THING.

**Marcela Valladolid** • Chef & TV Personality

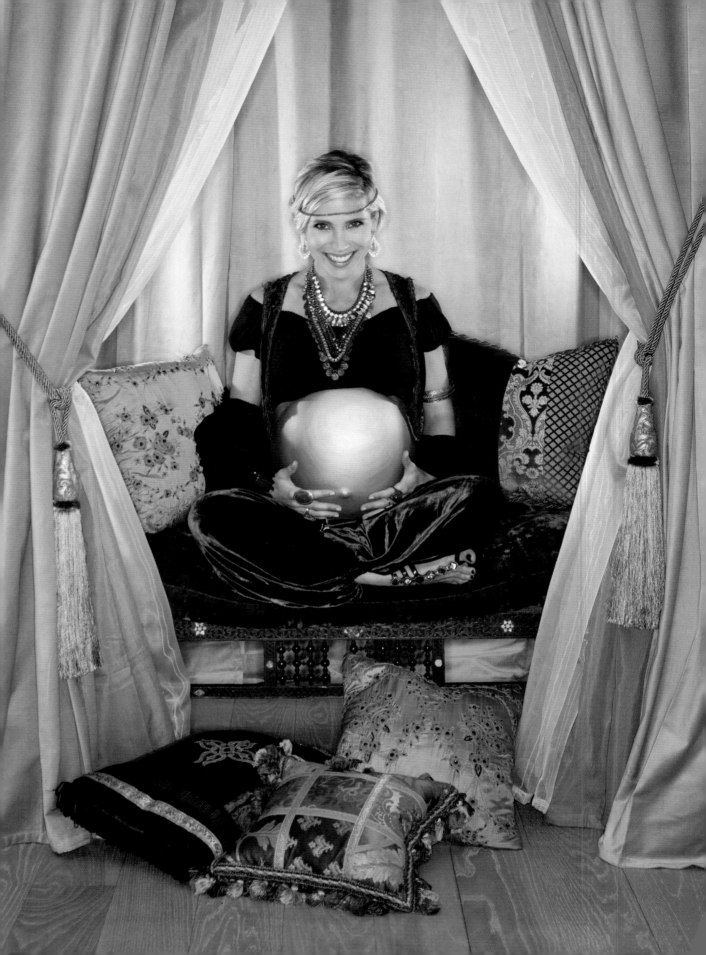

Life won't be the same.

# IT'll BE
# BIGGER
# AND BETTER.

CRYSTAL BALL

**Elsa Pataky** • Model, Actress

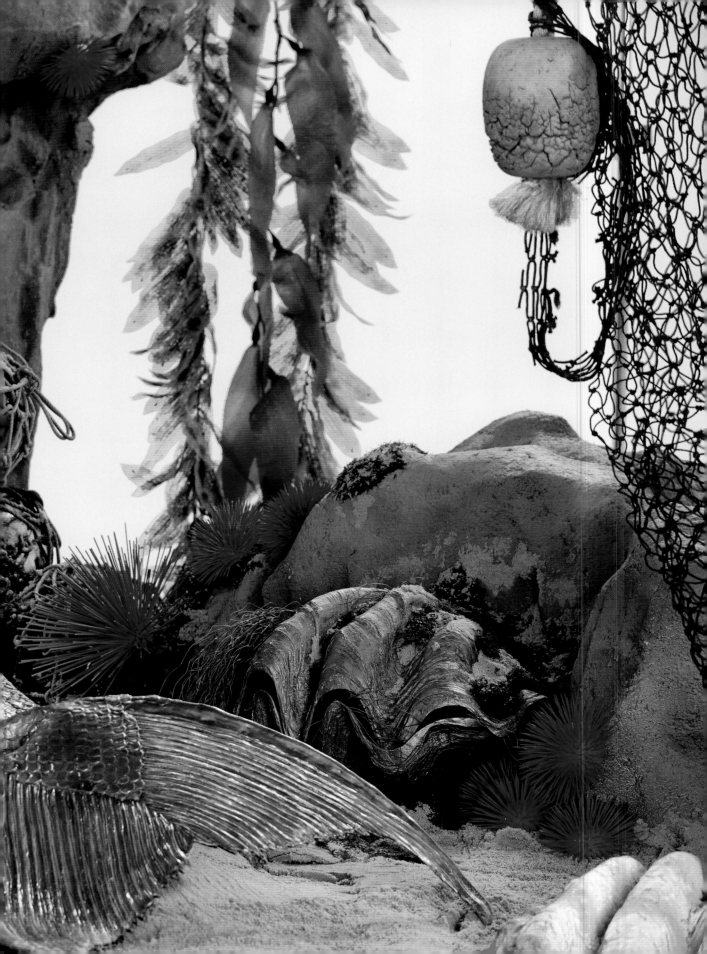

THE FISH

Leonor Varela • Actress

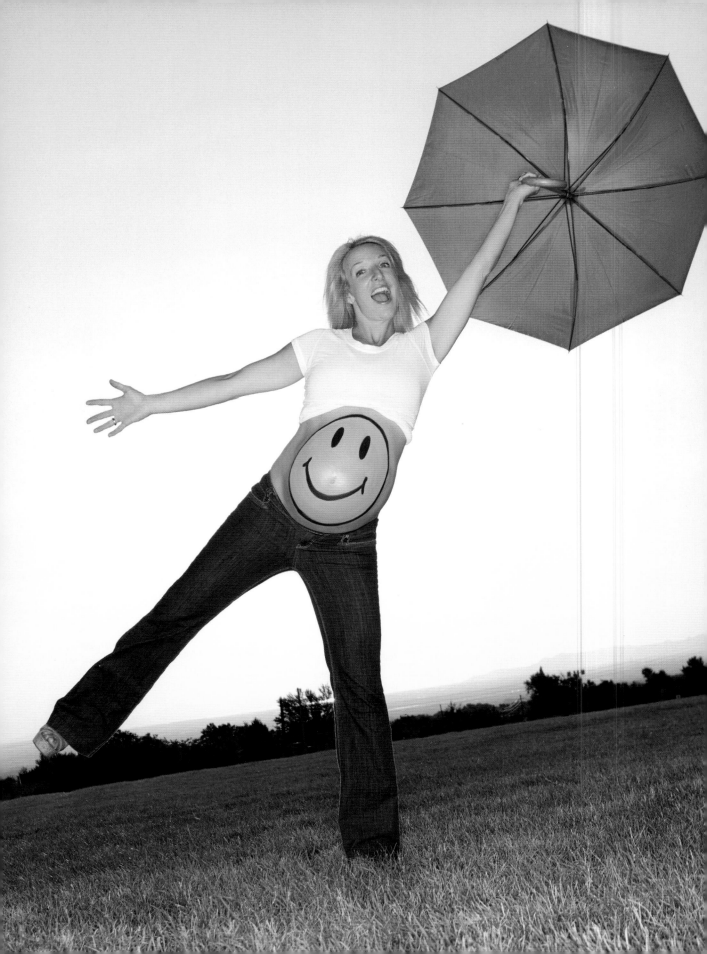

JUST KEEP
SMILING...

FOR NINE MONTHS!

**SMILEY FACE**

**Shannon Bahrke Happe** • 2X US Olympic Medalist in Freestyle Mogul Skiing, Entrepreneur

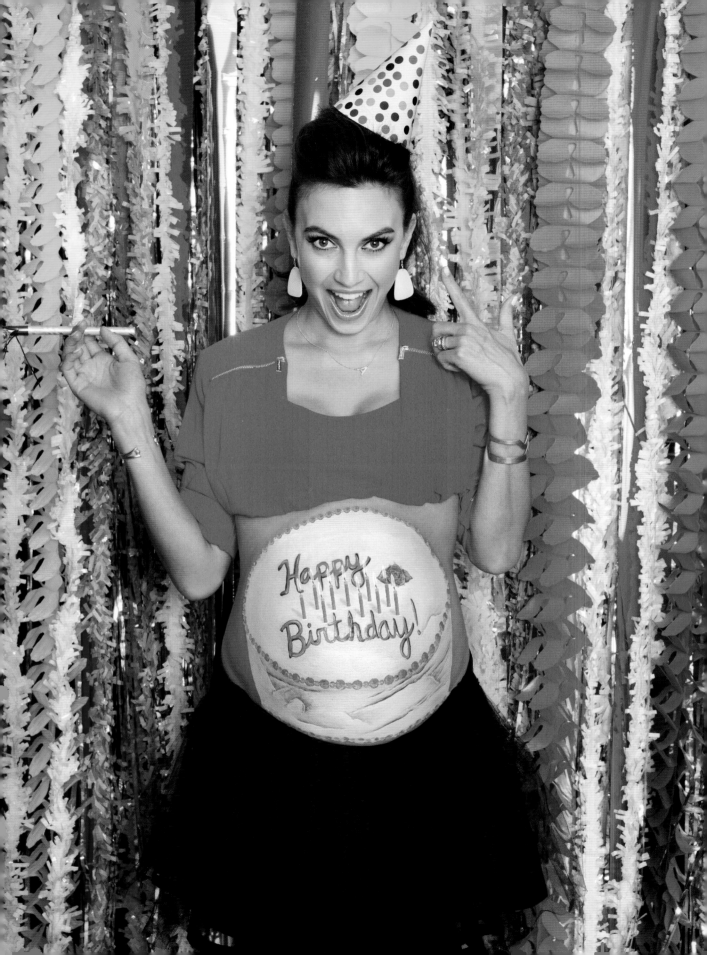

*You're Doing Something Amazing. So Celebrate You!*

BIRTHDAY CAKE

**Elizabeth Chambers** • Journalist, Entrepreneur, Owner of BIRD Bakery

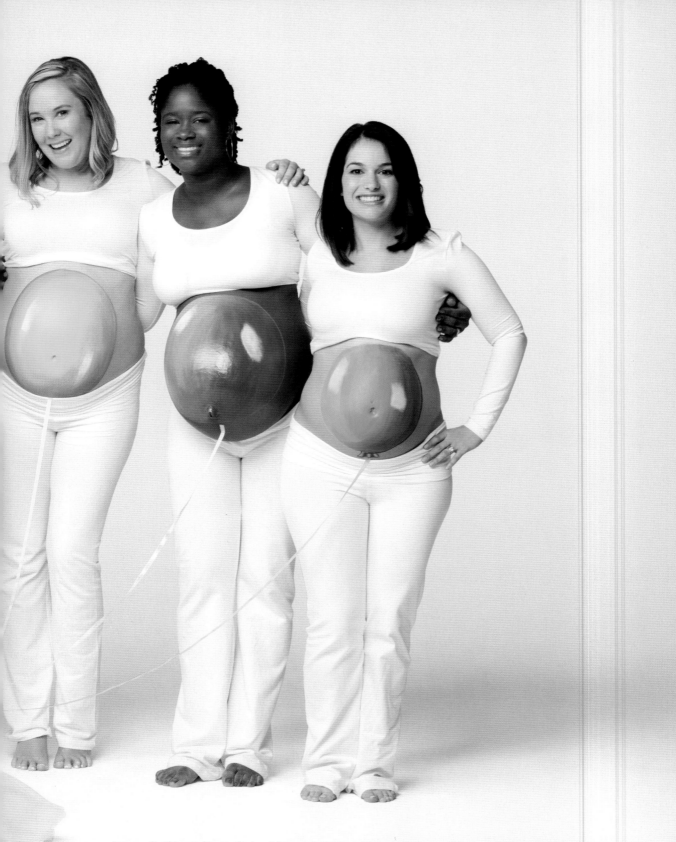

L→R  **Jenae S. Chevalier** • Sales Manager  **Jasmine White** • Assistant Director, Film & TV
**Michelle Rishel** • Senior Planning Manager, Spanx  **Lacy Coker** • Special Education Teacher
**Alicia Oseikwasi-Glasford** • Behavioral Health Care Planner  **Jennifer Sabel** • Sales

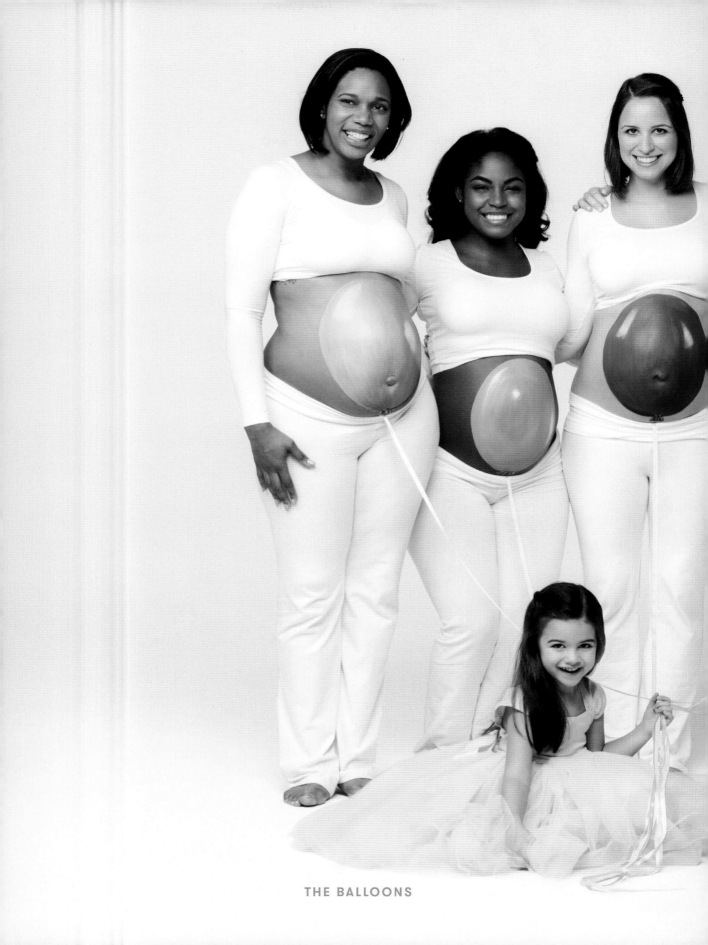

THE BALLOONS

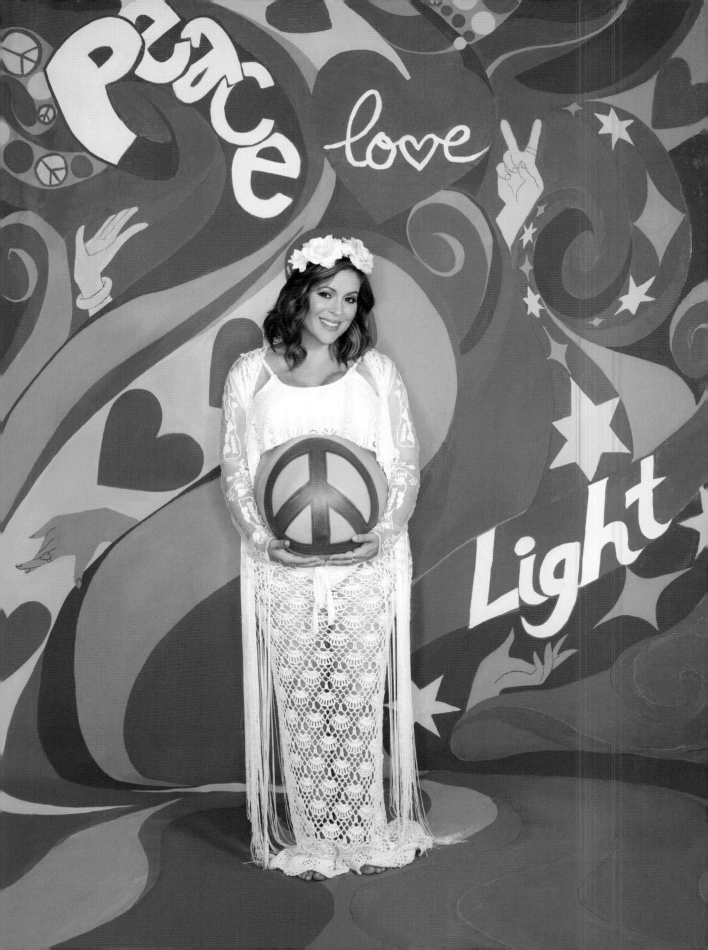

LET GO OF "should" AND JUST GO WITH THE flow...

PEACE SYMBOL

**Alyssa Milano** • Activist, Host, Actress, Producer

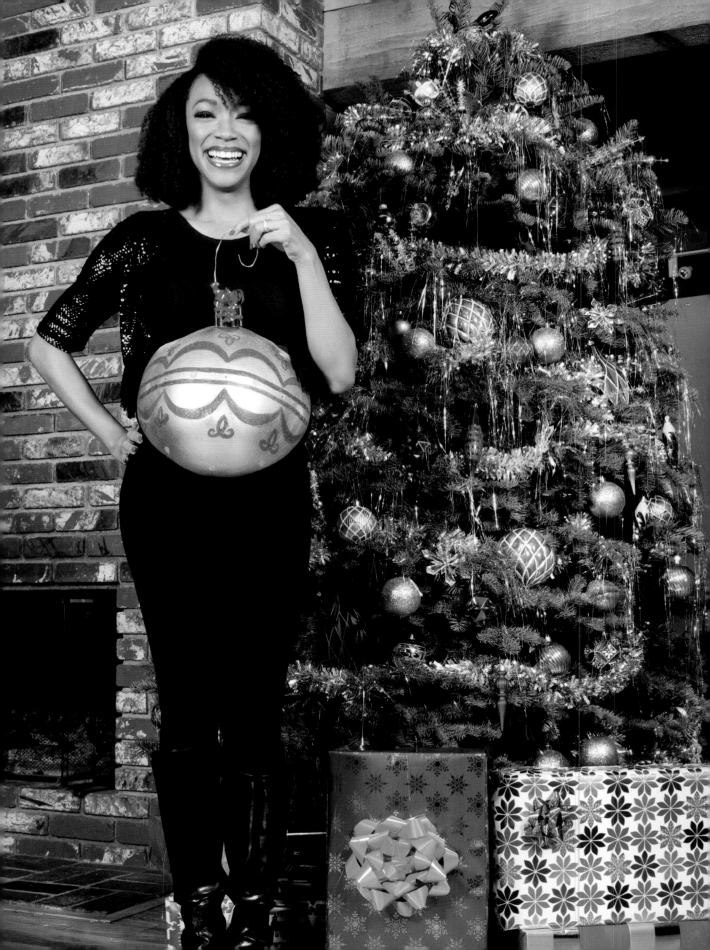

# JOY to THE WORLD

**THE ORNAMENT**

**Sonequa Martin-Green** • Actress, Producer

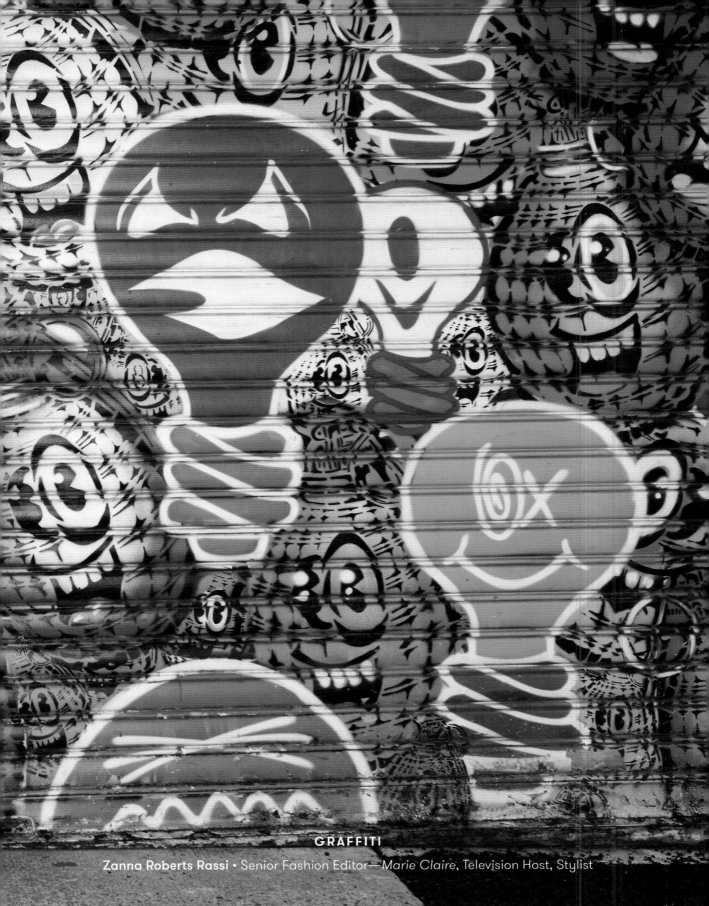

GRAFFITI

**Zanna Roberts Rassi** • Senior Fashion Editor—*Marie Claire*, Television Host, Stylist

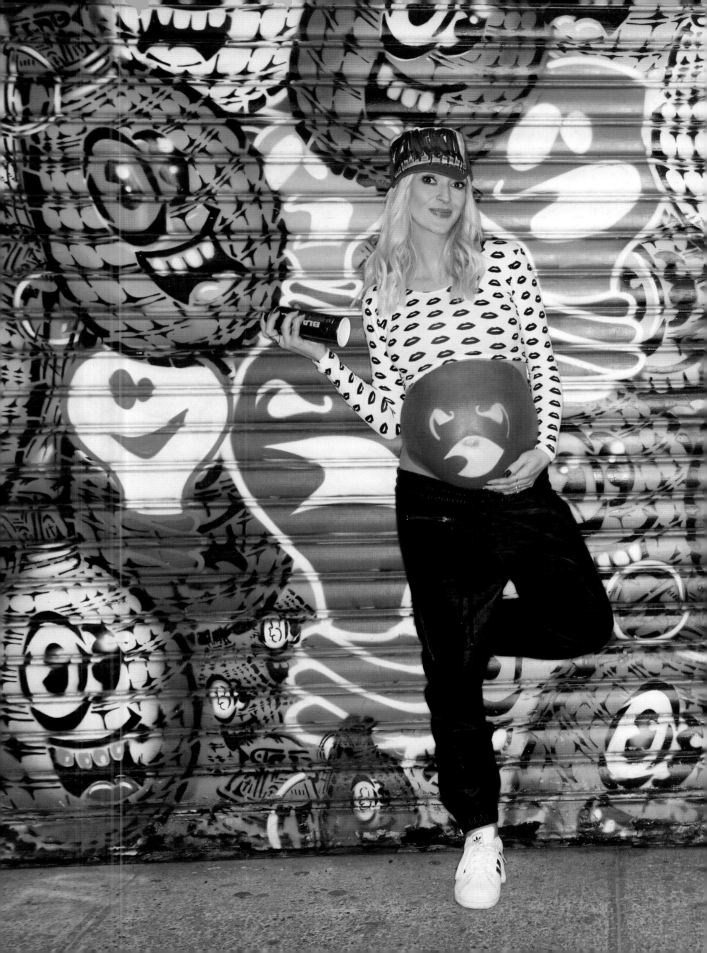

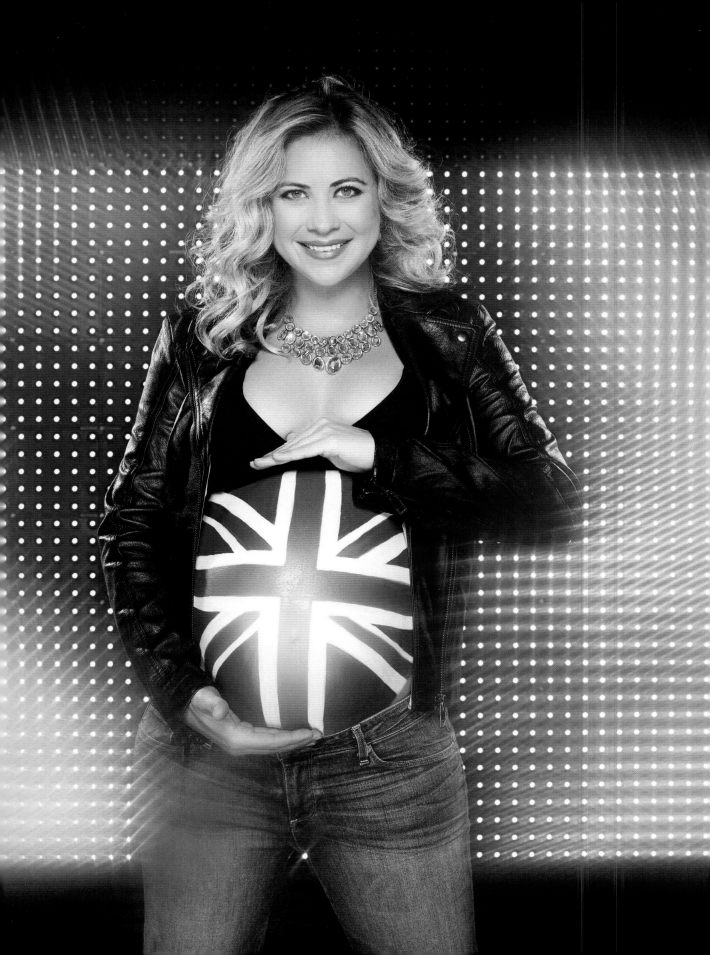

BE
PROUD.

YOU'RE CHANGING
THE WORLD!

**THE UNION JACK**

**Holly Branson** • Special Projects—Virgin Group

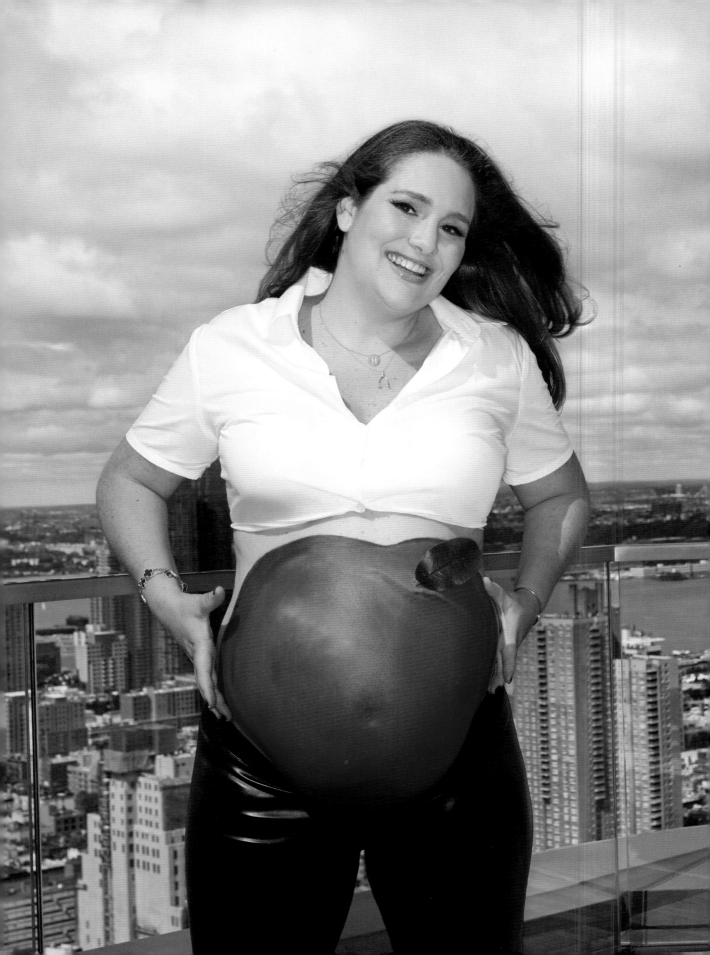

BIG APPLE, BIG LOVE

NYC APPLE

**Gillian Hearst Simonds** • Contributing Editor, Town & Country

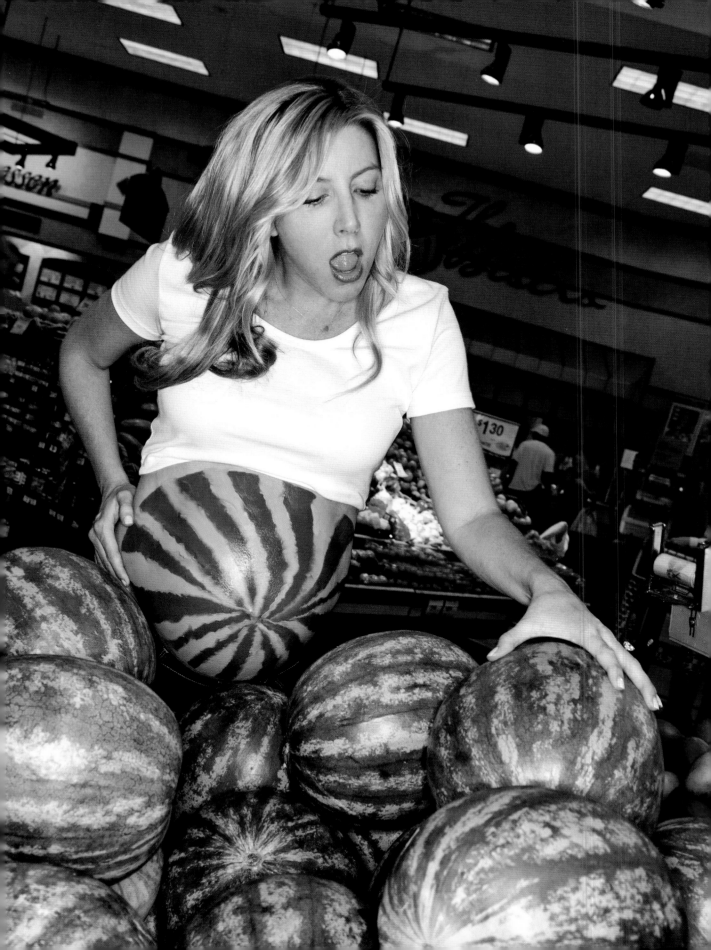

# 100% ORGANIC!

WATERMELON

**Sara Blakely** • Founder/Owner—Spanx and Sara Blakely Foundation

FLOWER

**Stephanie Schur** • Florist

# circles for *girls*

...or was that the other way round?!

wedding ring on a string

spins...

*side*

*to*

*side*

*for*

*boys*

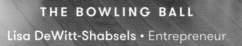

THE BOWLING BALL

Lisa DeWitt-Shabsels • Entrepreneur

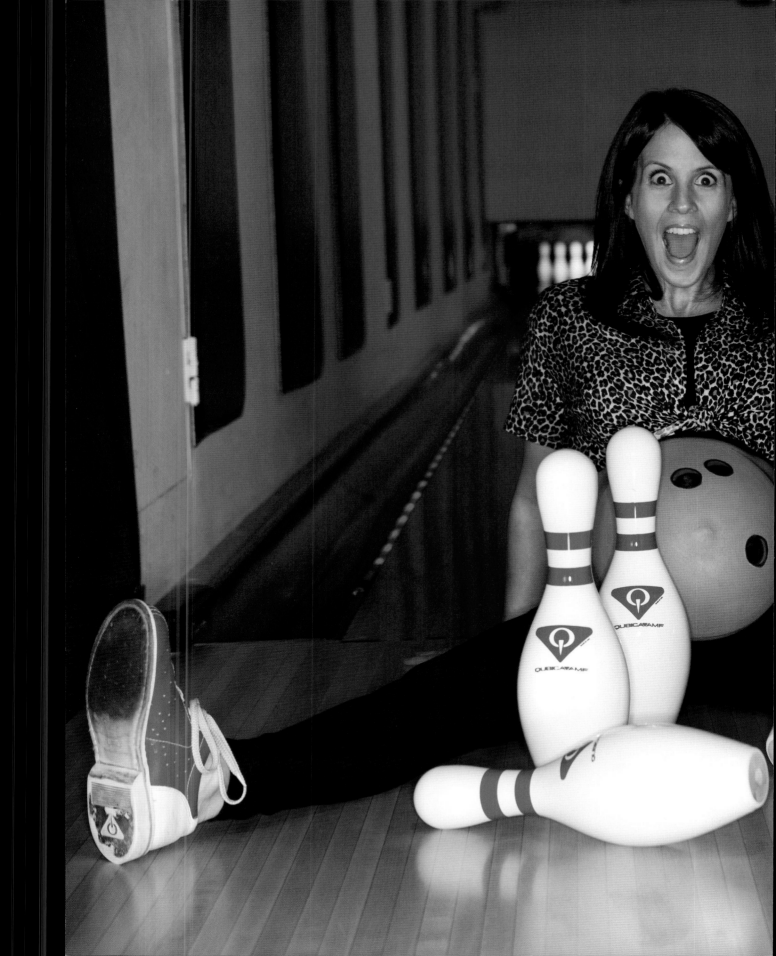

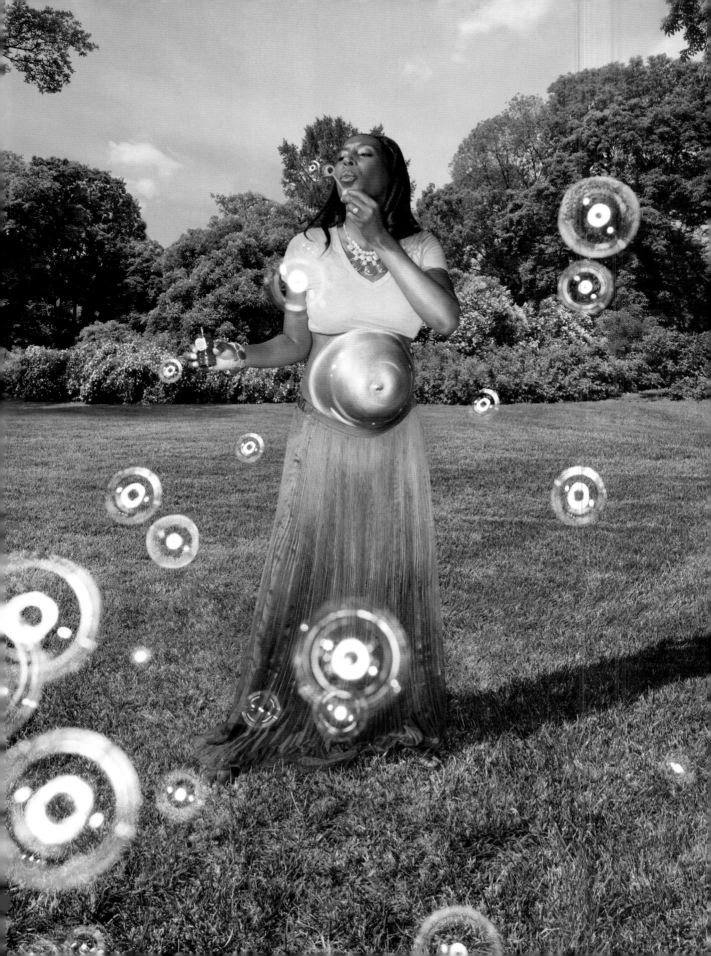

# GLOWING
## AND
# GROWING

**THE BUBBLE**

**Nicole Schlegel** • Digital Marketing Coordinator, Universal Pictures

EYES
ON THE
PRIZE,
BABY!

THE BRONZE MEDAL

**Shannon Bahrke Happe** • 2X US Olympic Medalist in Freestyle Mogul Skiing, Entrepreneur

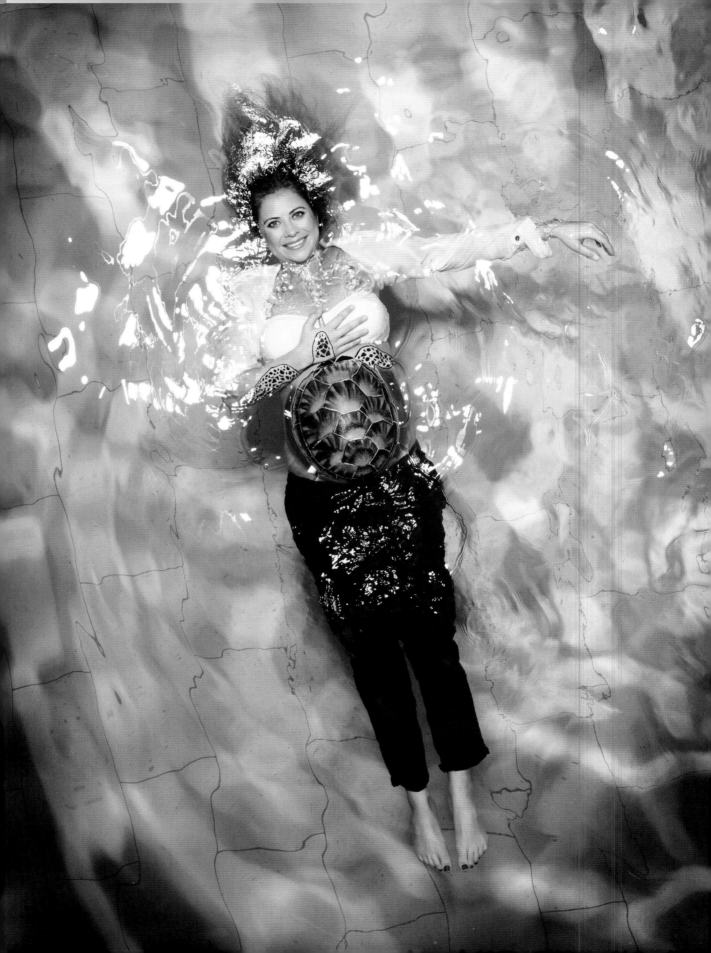

IT'S THE WORLD'S
MOST *lovely*
SURPRISE

**TURTLE**

**Holly Branson** • Special Projects—Virgin Group

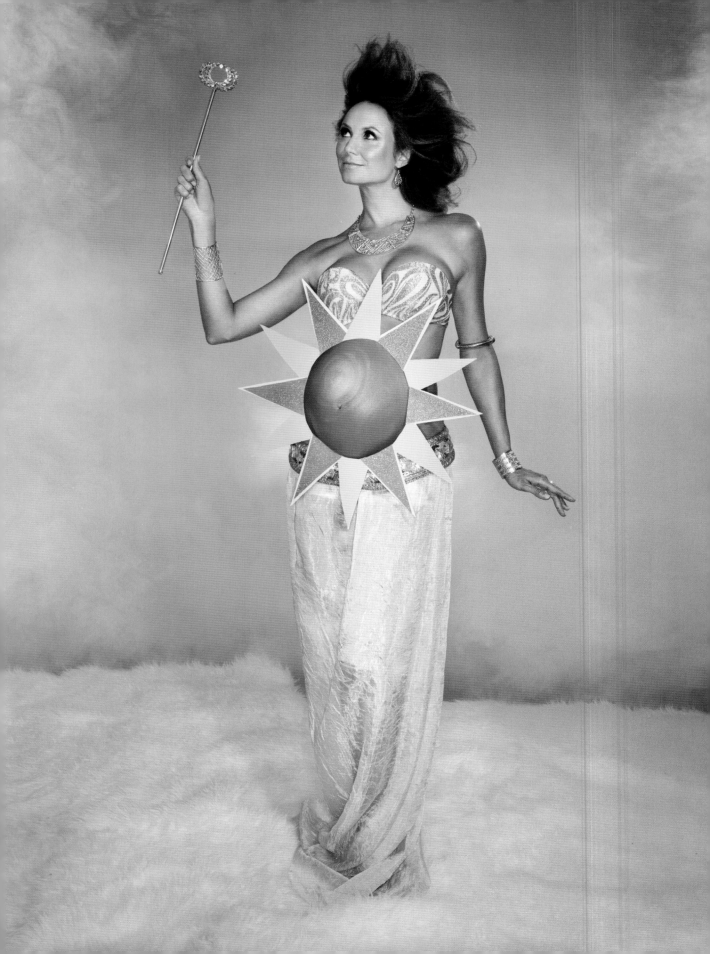

# SUNNY DAYS AHEAD!

**Stacy Keibler** • Health Advocate, Entrepreneur, Actress, Host

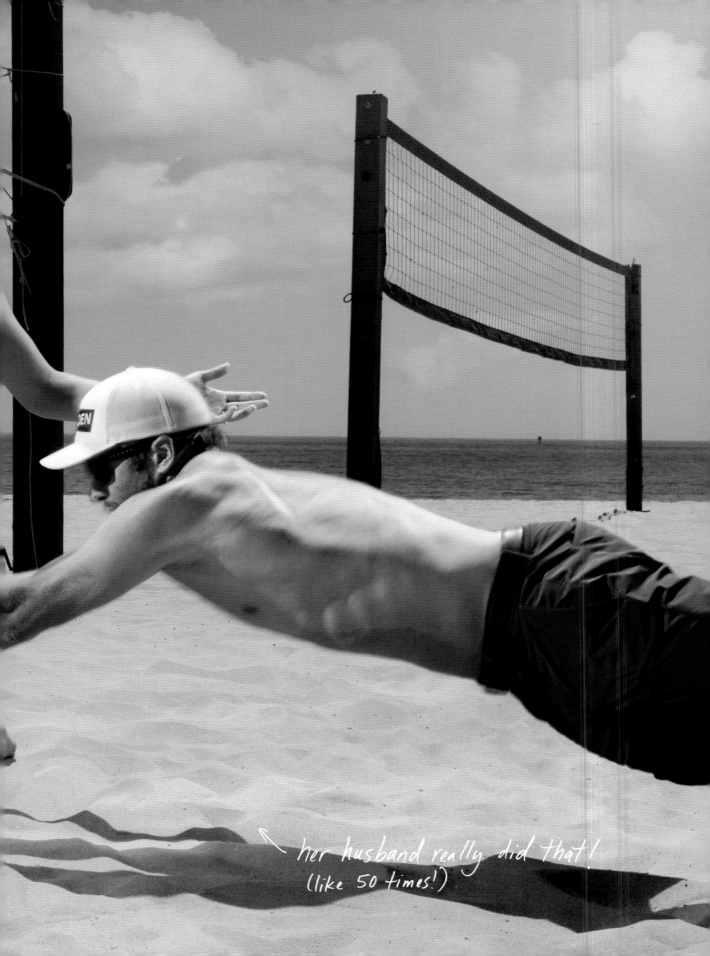

her husband really did that!
(like 50 times!)

VOLLEYBALL

**Morgan Beck Miller** • Professional Beach Volleyball Player

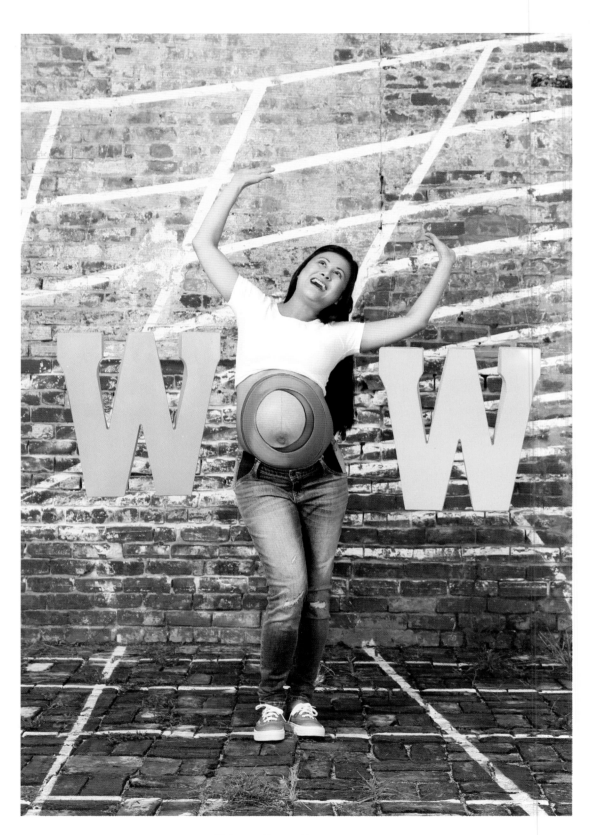

**Shirene Free** • Entrepreneur

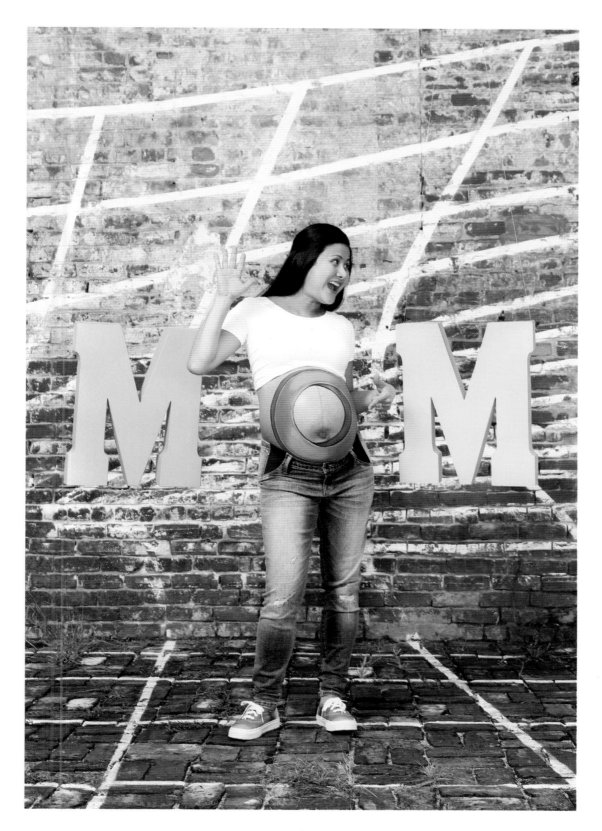

MOM/WOW

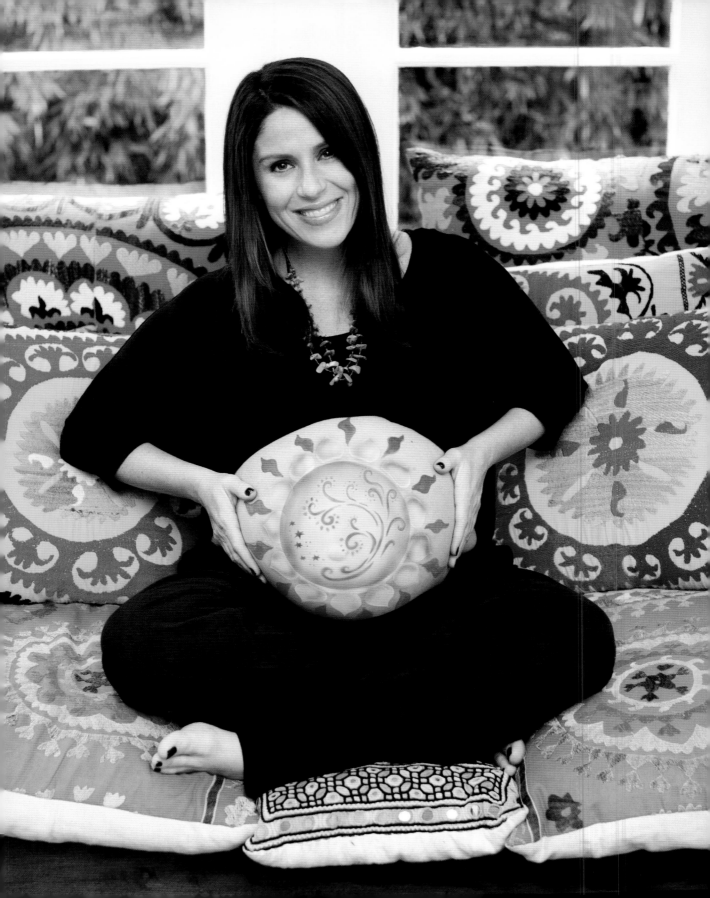

JUST BE COMFY IN YOUR OWN SKIN

SUZANI PILLOW

**Soleil Moon Frye** • Actress, Author, Blogger

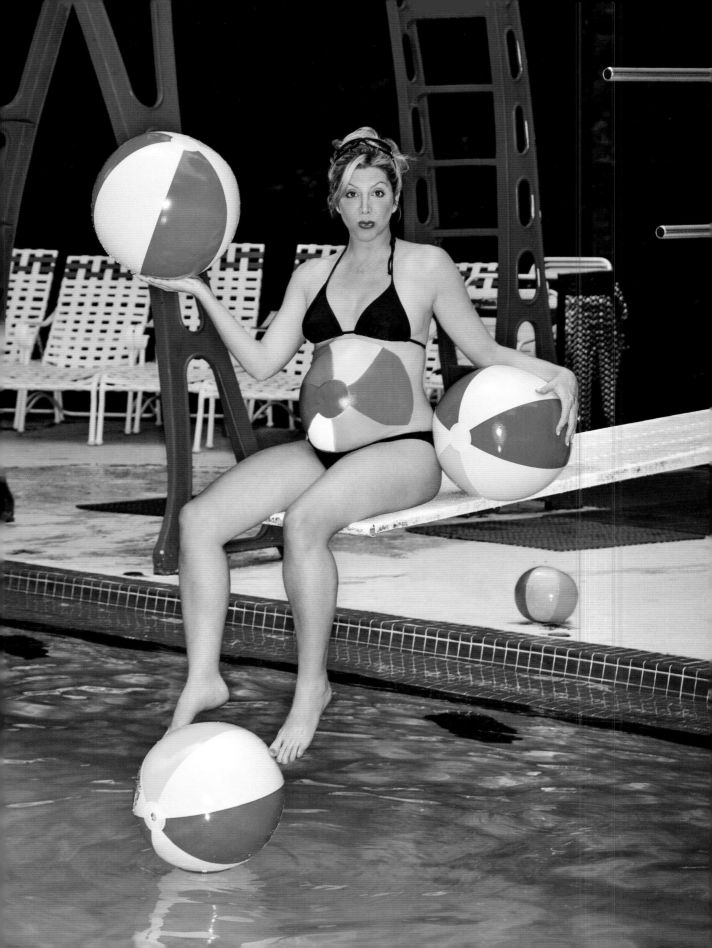

# Belly up!

BEACH BALL

**Sara Blakely** • Founder/Owner—Spanx and Sara Blakely Foundation

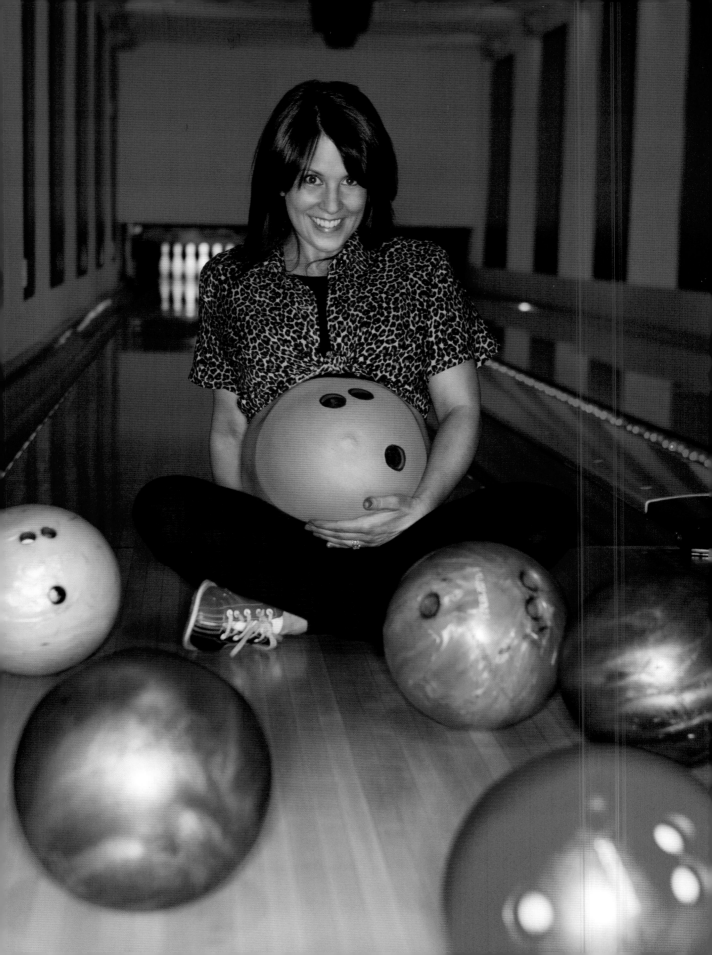

JUST

ROLL

WITH IT!

**BOWLING BALL**

**Lisa DeWitt-Shabsels** • Entrepreneur

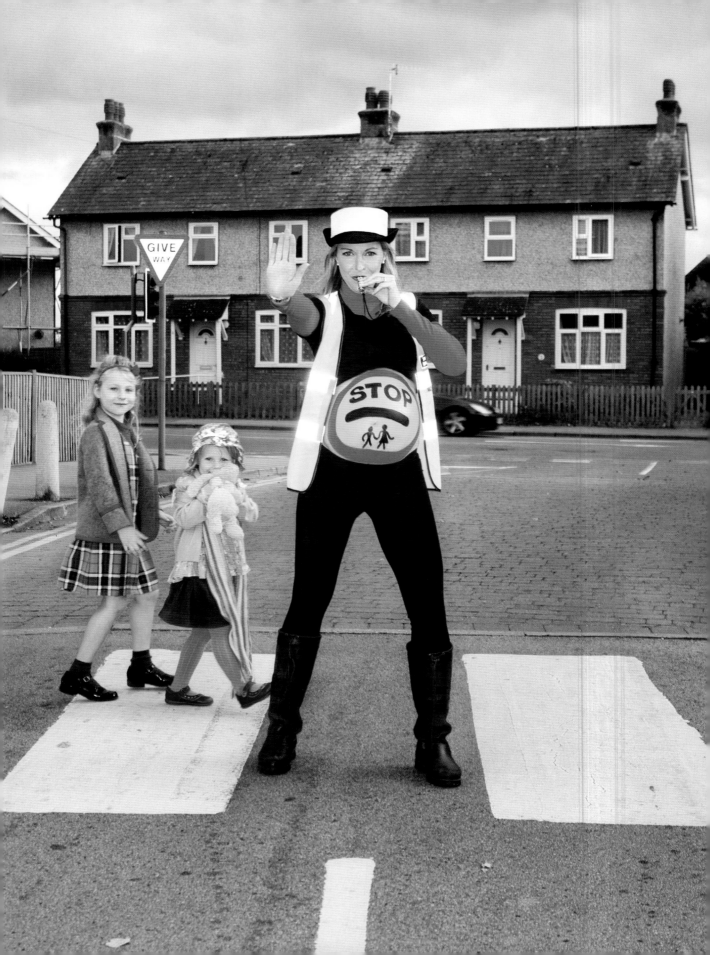

OBEY THE BELLY!

**SCHOOL CROSSING GUARD**

**Niki Perry** • Yoga Instructor

**BILLIARD BALL**

Alicia Roye Chestnut • Air Force Veteran, Legal Analyst

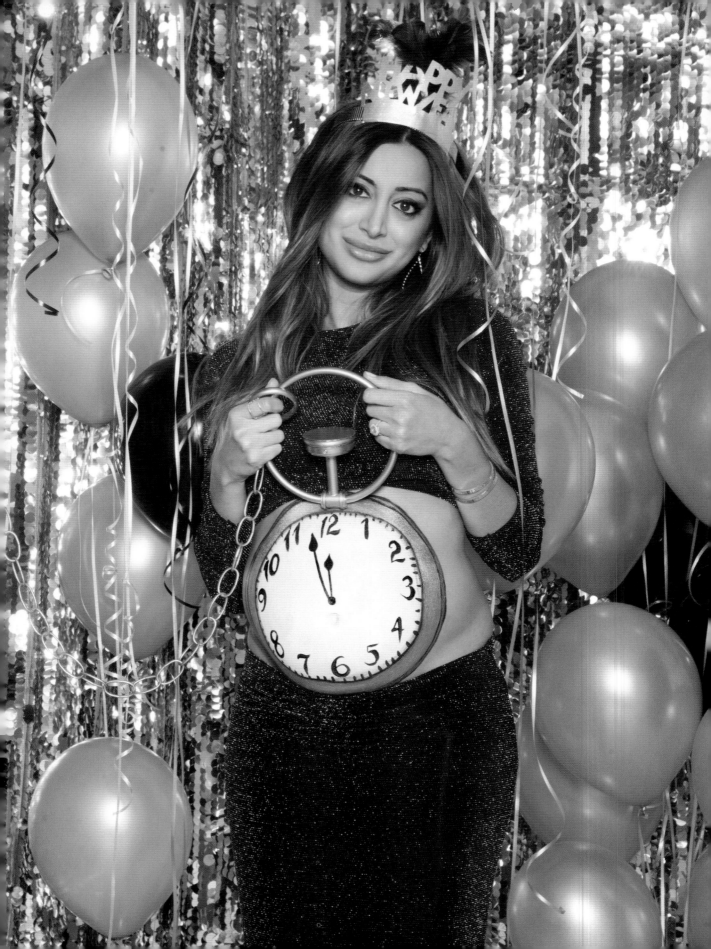

# WORTH THE WAIT!

CLOCK

**Noureen DeWulf** • Actress

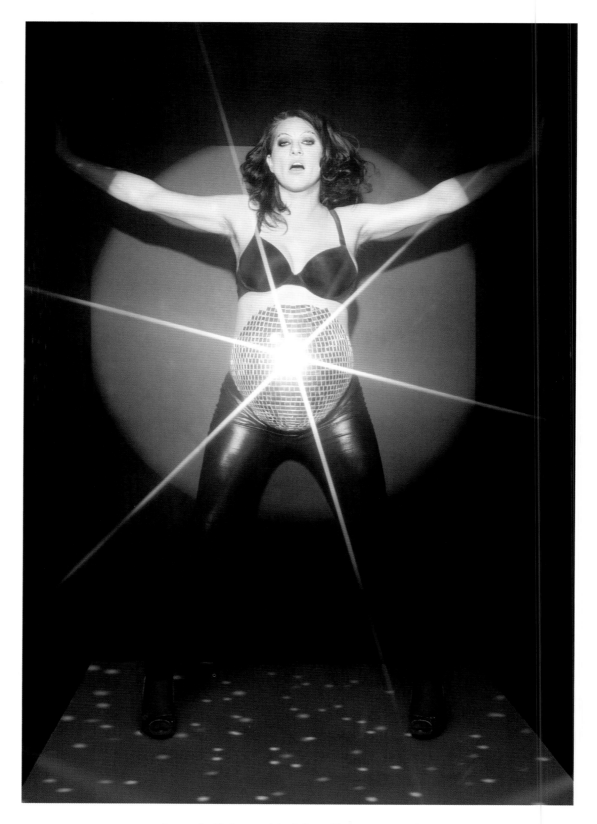

**Amanda Palmer** • Musician, Singer-songwriter

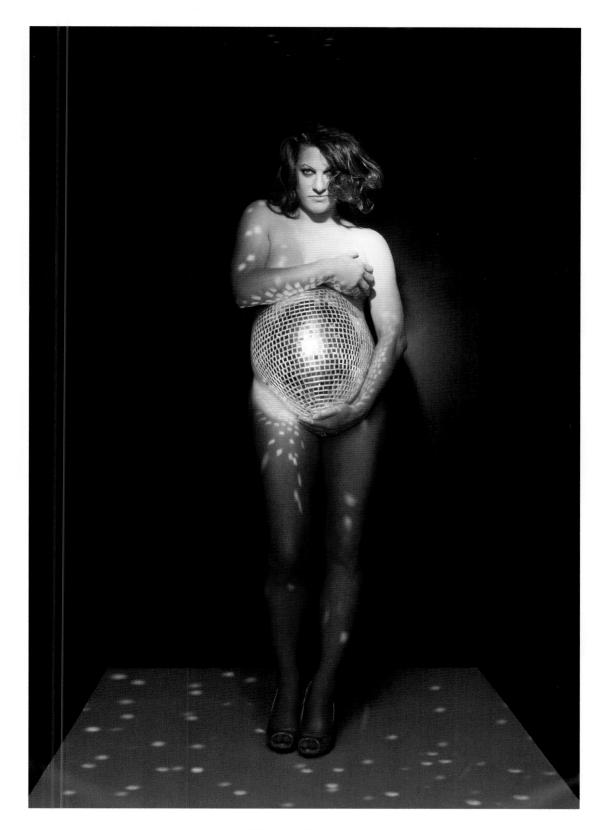

**THE DISCO BALL**

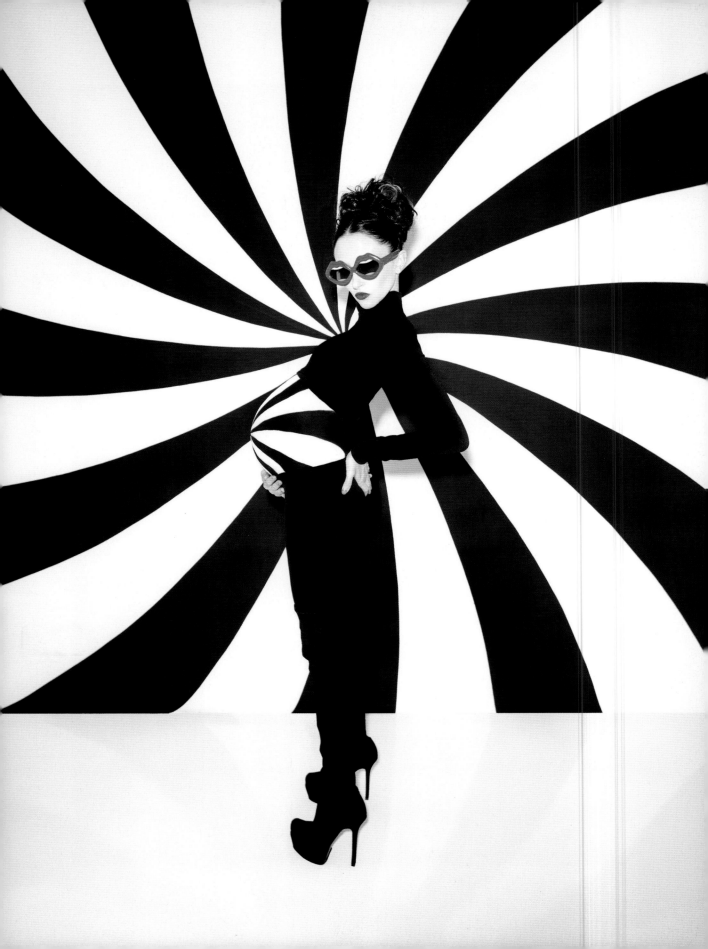

ROCK
*THAT*
BELLY

**OP ART**

**Stacey Bendet** • Founder, CEO and Creative Director of Alice + Olivia

**MARS**

Nicole Schlegel • Digital Marketing, Universal Pictures

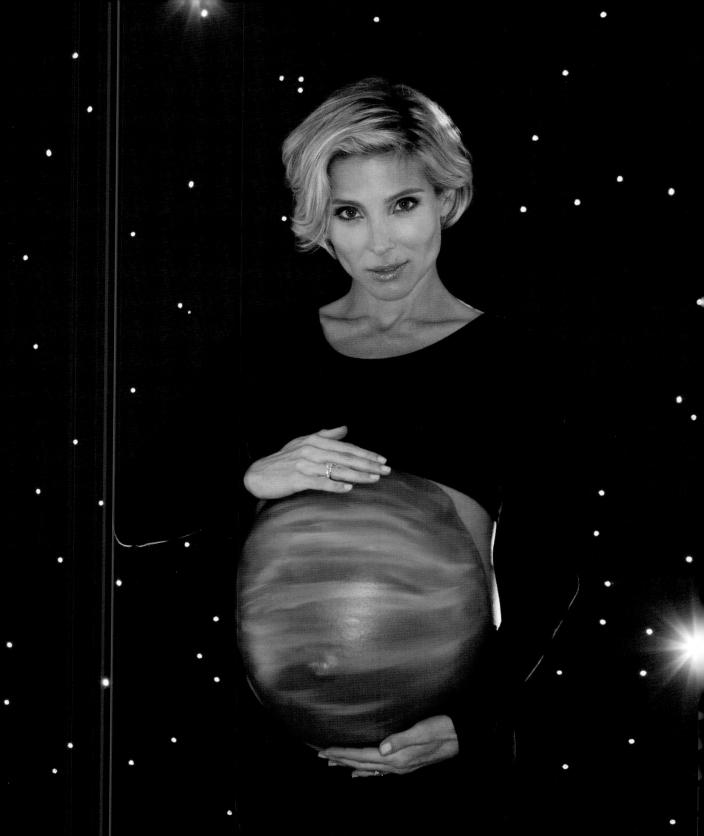

**NEPTUNE**

Elsa Pataky • Model, Actress

MERCURY

Noureen DeWulf • Actress

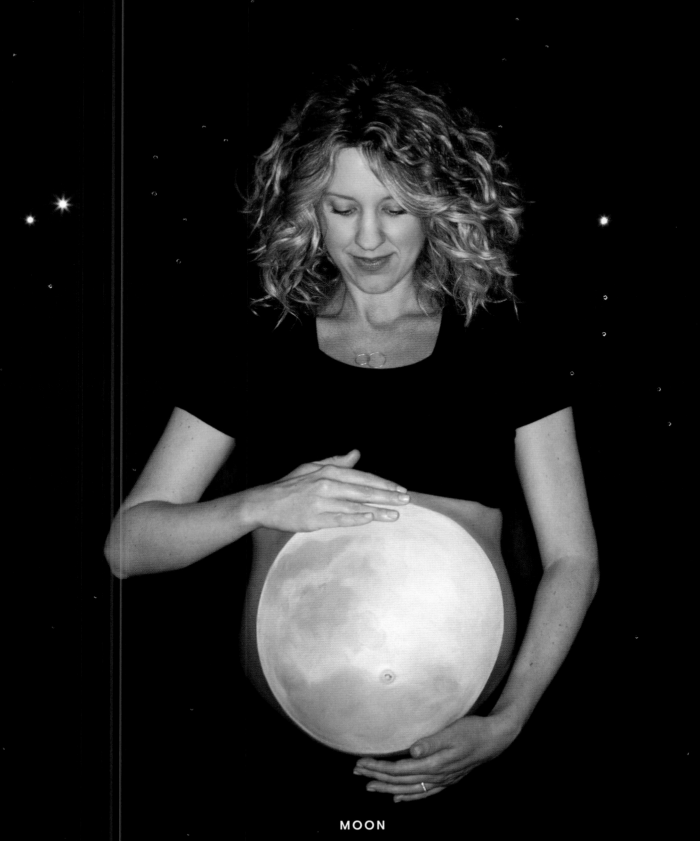

## MOON

**Maggie Adams Klein** • Senior Marketing Director, Spanx

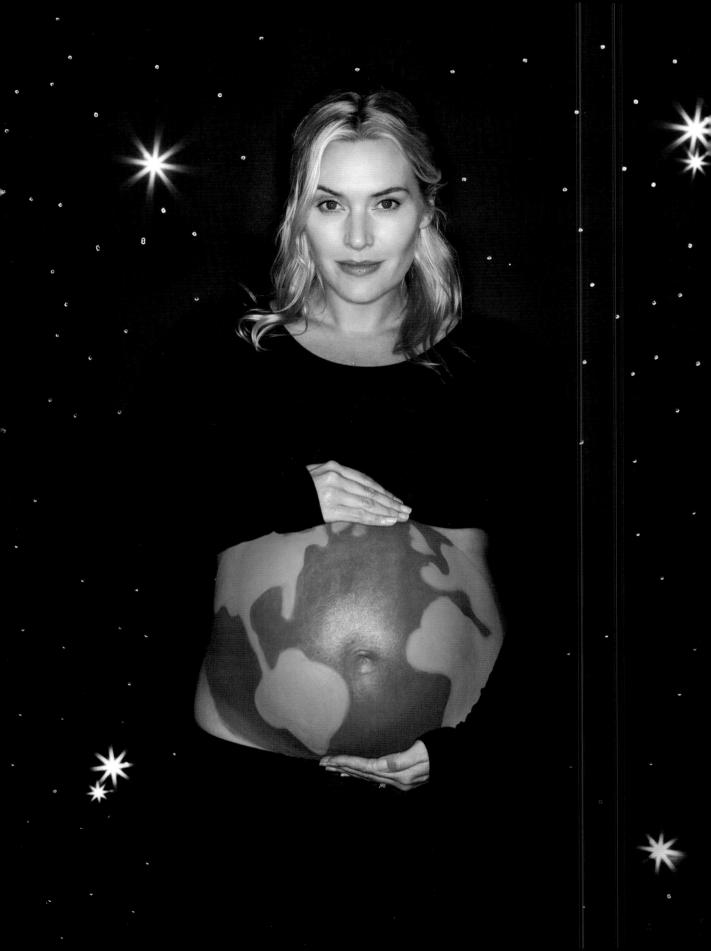

*mothers make the world go round*

EARTH

**Kate Winslet** • Actress

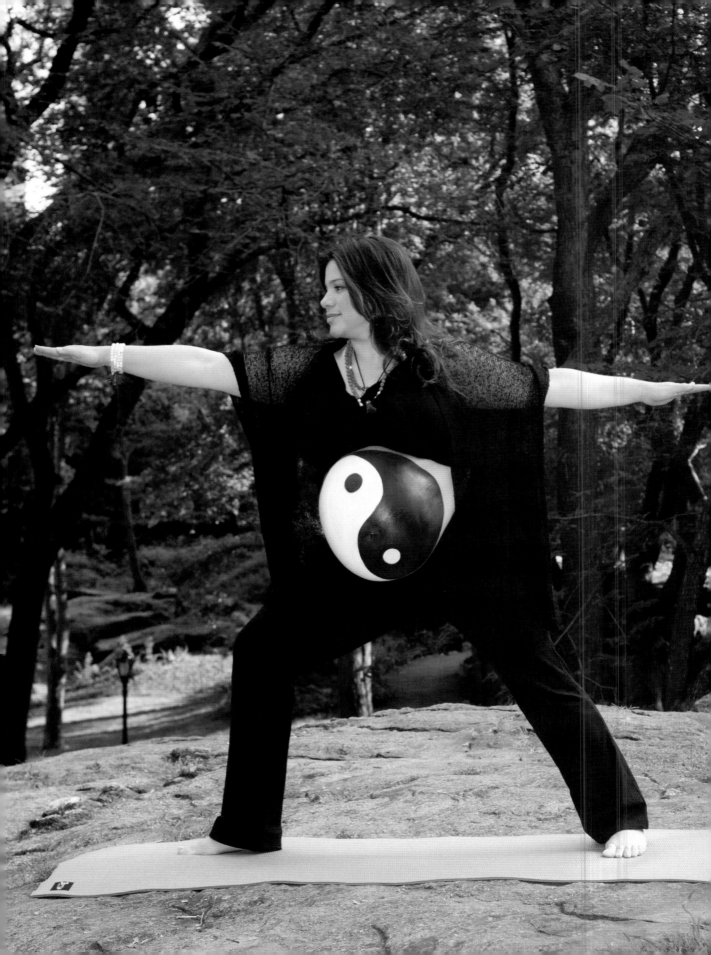

BREATHE,
BALANCE AND
EMBRACE
THE
BEAUTY

**YIN-YANG**

**Rachel P. Goldstein** • Founder + CEO, Agent of Change Network

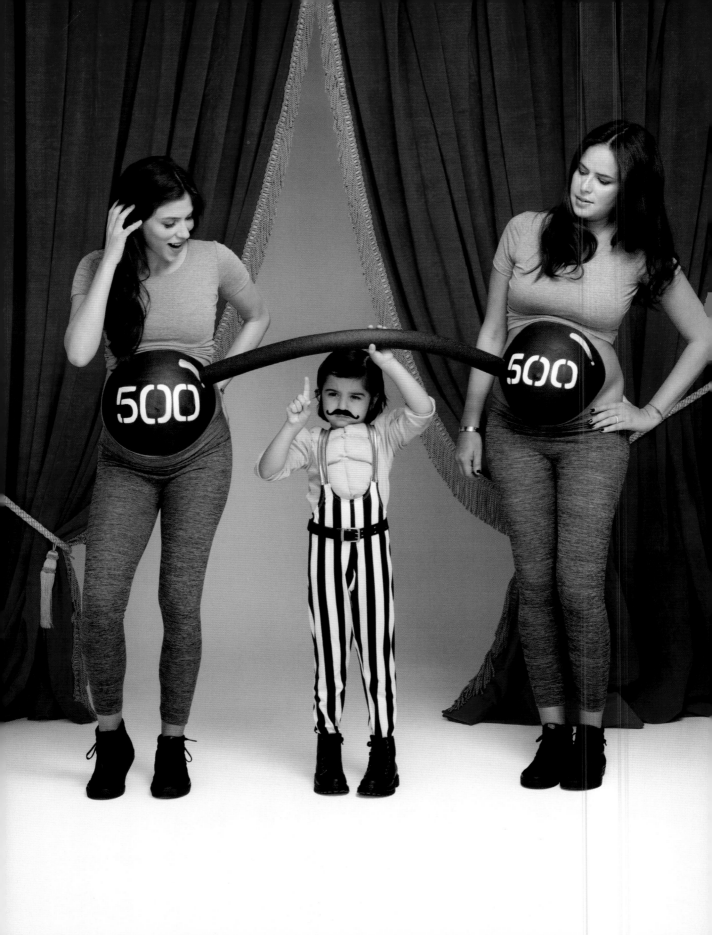

NOTHING TAKES
MORE
STRENGTH
THAN MAKING
A BABY.

Alida Boer • Miss Guatemala 2007, Founder/CEO Maria's Bag   Rachel Katz • Attorney

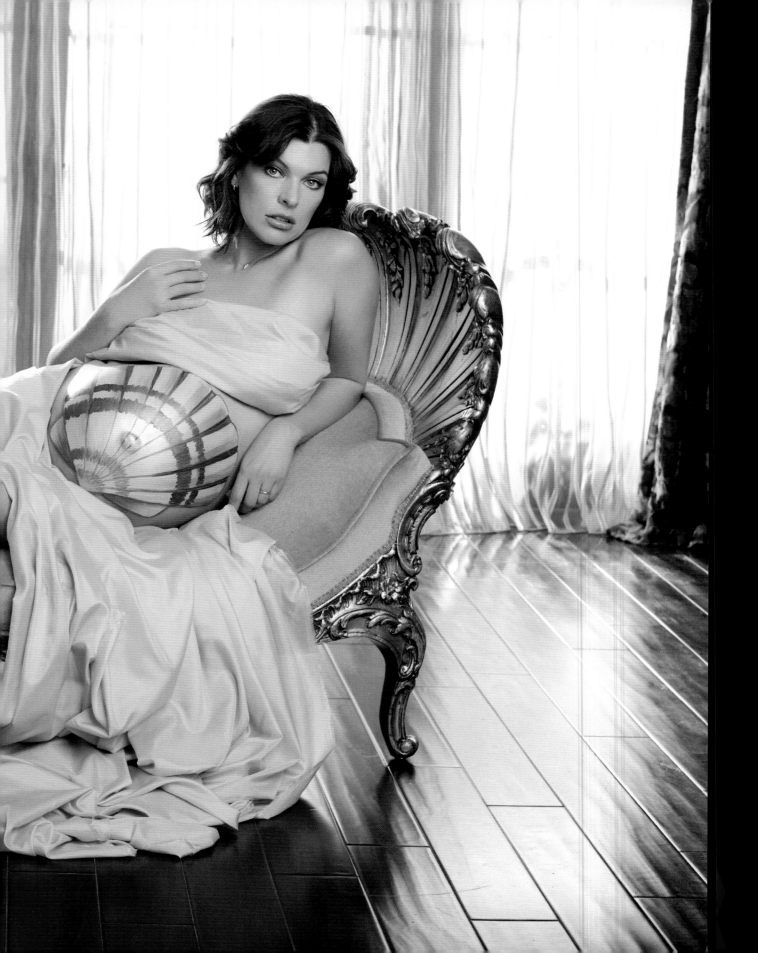

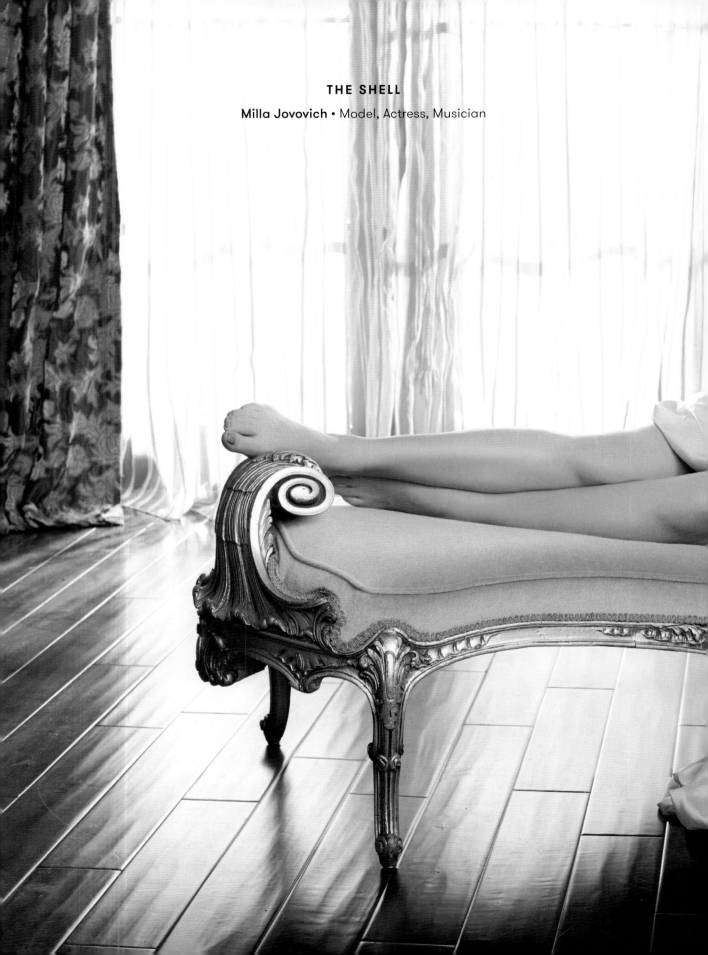

# THE SHELL

**Milla Jovovich** • Model, Actress, Musician

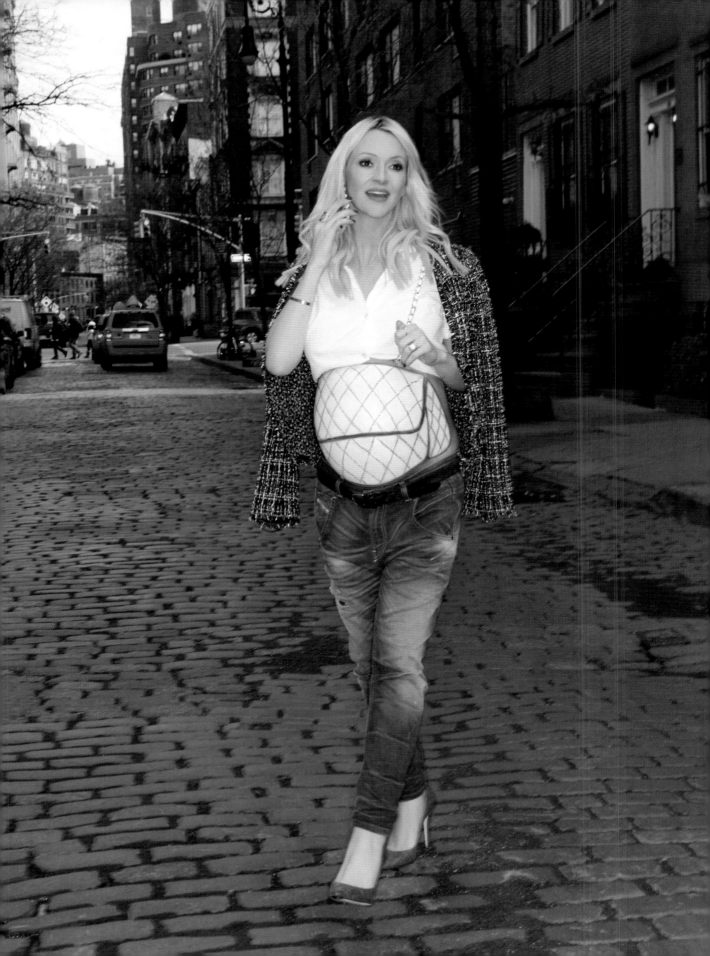

**THE HANDBAG**

**Zanna Roberts Rassi** • Senior Fashion Editor—*Marie Claire*, Television Host, Stylist

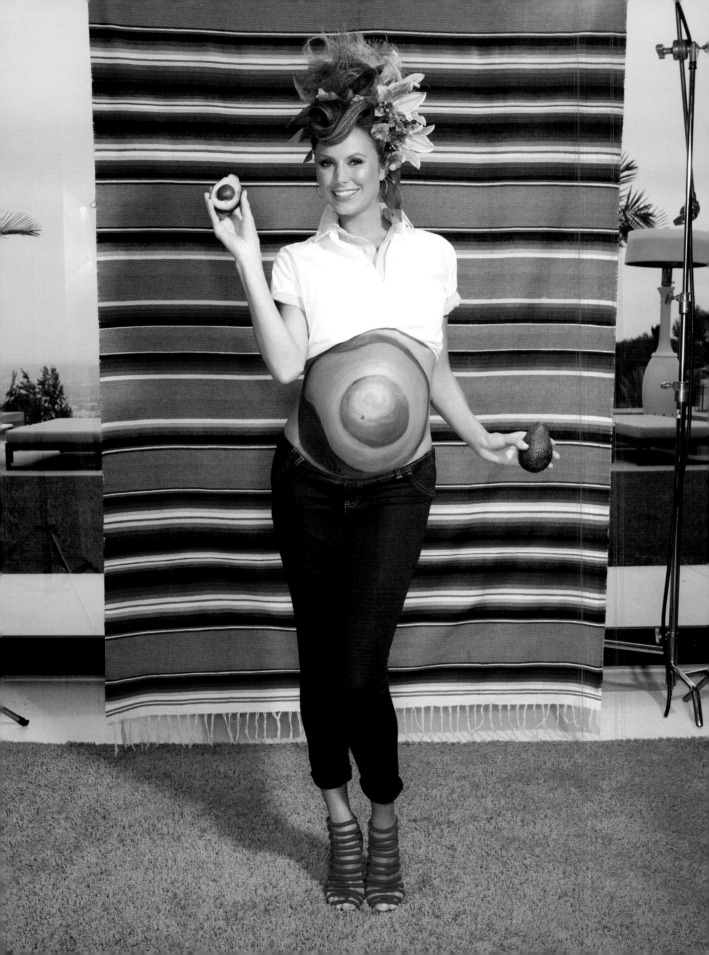

*Bellylicious*

**AVOCADO**

**Stacy Keibler** • Health Advocate, Entrepreneur, Actress, Host

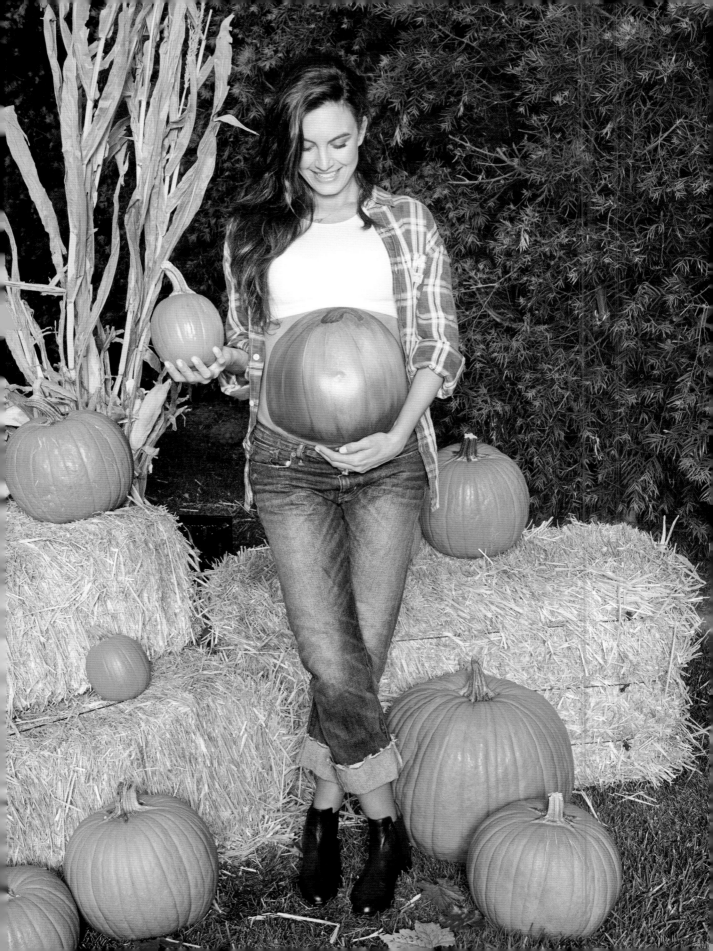

it's crazy
WHAT YOUR
BODY CAN DO.

WHO KNEW?!?

**PUMPKIN**

**Elizabeth Chambers** • Journalist, Entrepreneur, Owner of BIRD Bakery

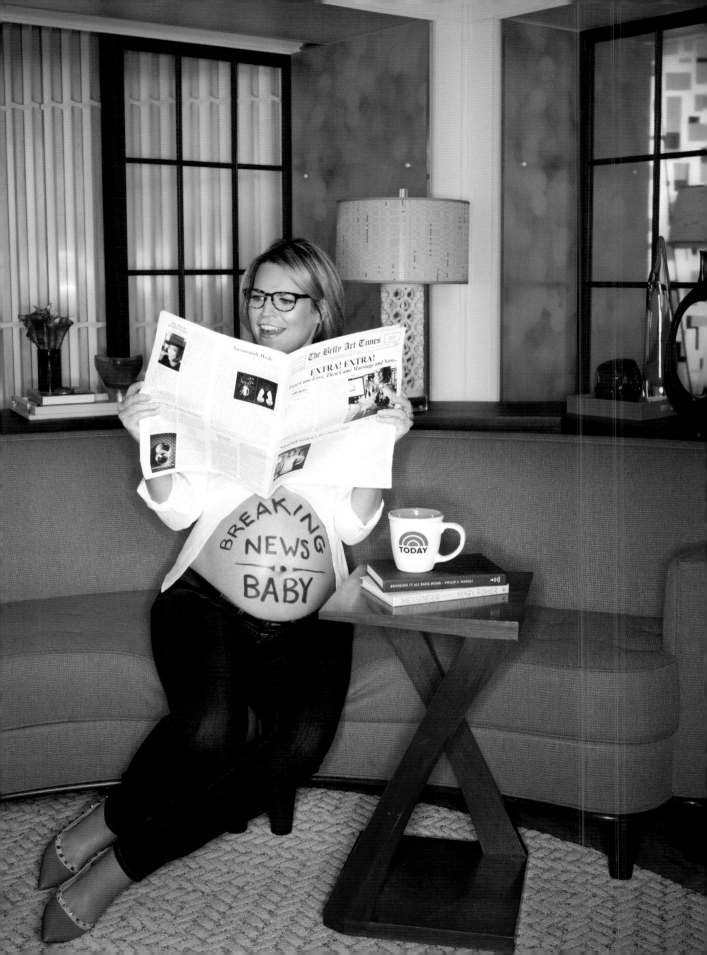

YOUR BABY TELLS YOU
WHAT IT NEEDS.
_____

LIKE
ICE CREAM!

BREAKING NEWS
**Savannah Guthrie** • Co-anchor of NBC's TODAY

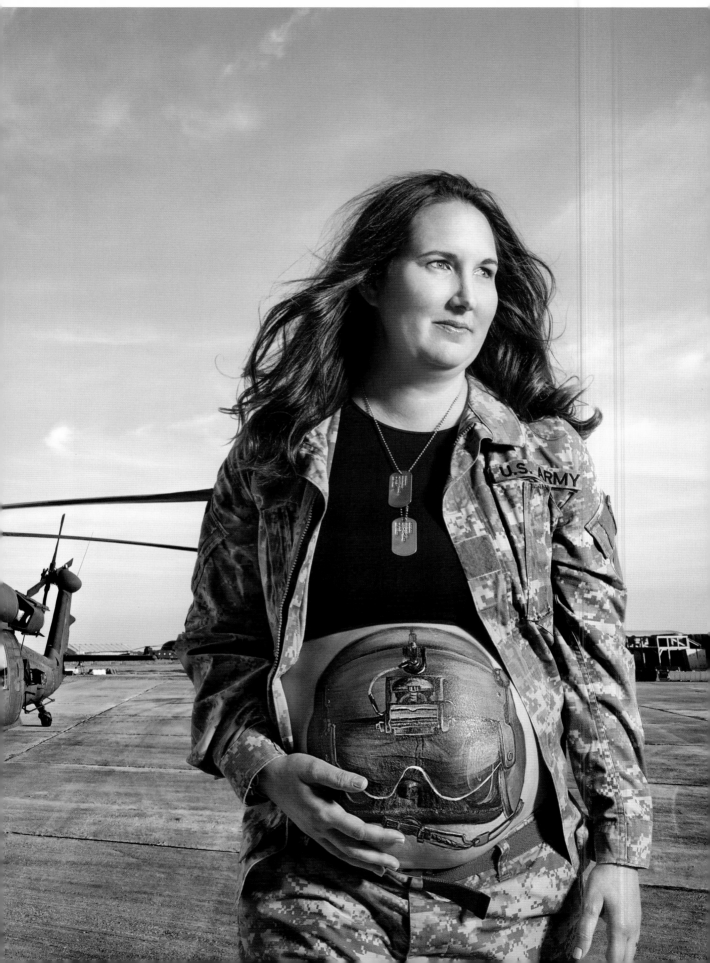

**BLACK HAWK HELMET**

**Anna Gordon** • Black Hawk Helicopter Pilot, US Army (Retired), Photographer

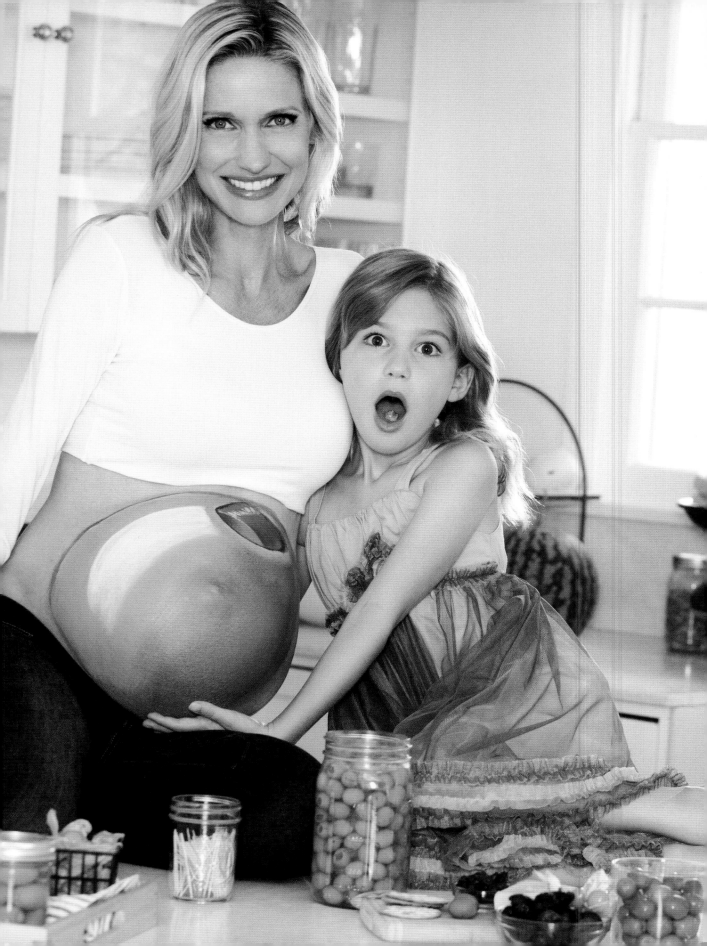

# LOVE EVERY STAGE.
## Just own it!

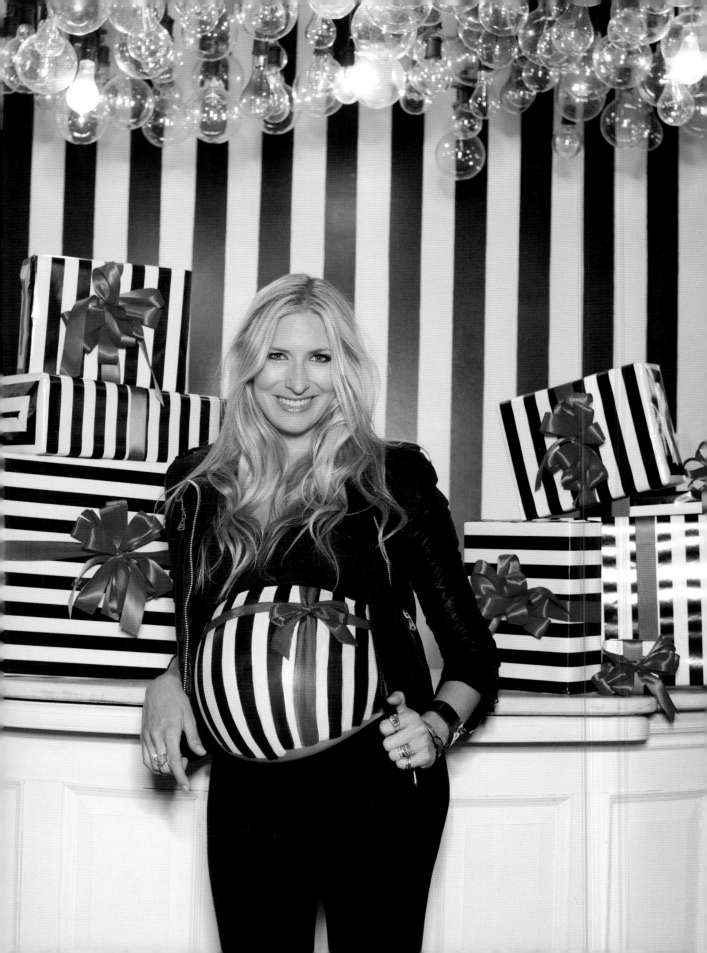

# LIFE'S GREATEST GIFT

## THE GIFT

**Holly Williams** • Musician, Singer-songwriter

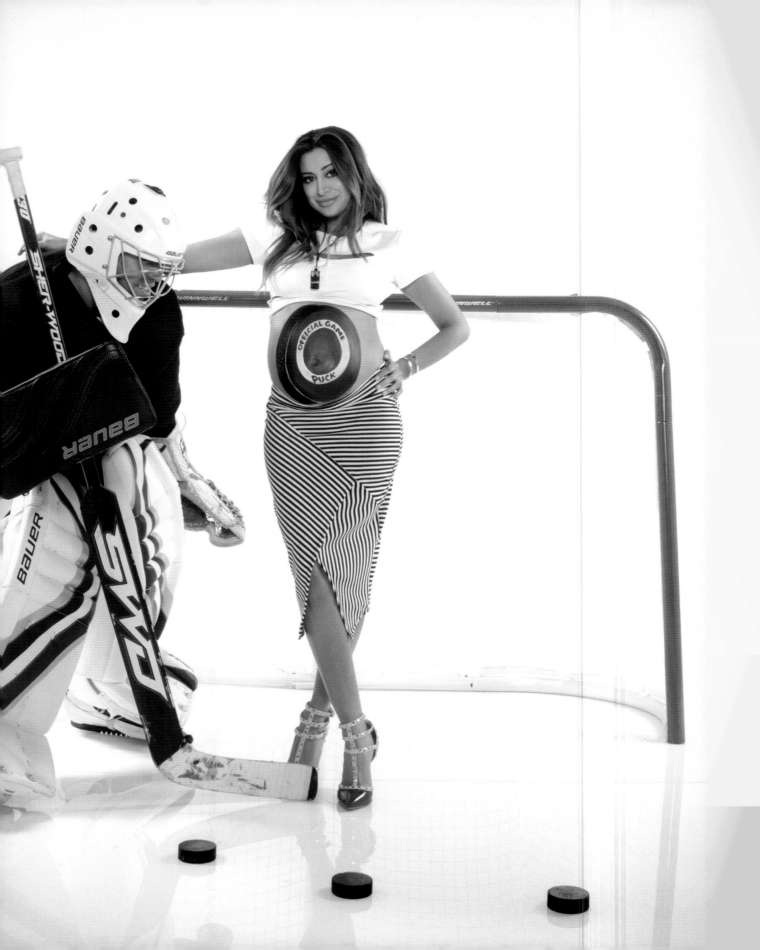

THERE IS
NO
MATCH
_____
FOR WHAT
A WOMAN'S
BODY
CAN DO!

HOCKEY PUCK

**Noureen DeWulf** • Actress

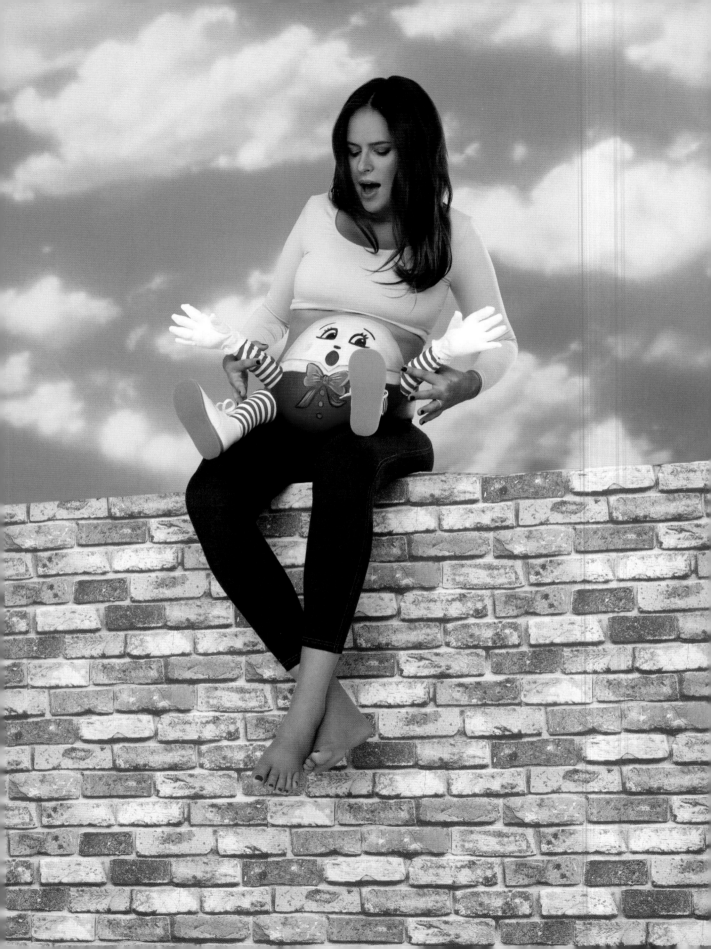

THERE'S NO
*rhyme* OR REASON

IT'S JUST A
*Miracle*

**HUMPTY DUMPTY**

Rachel Katz • Attorney

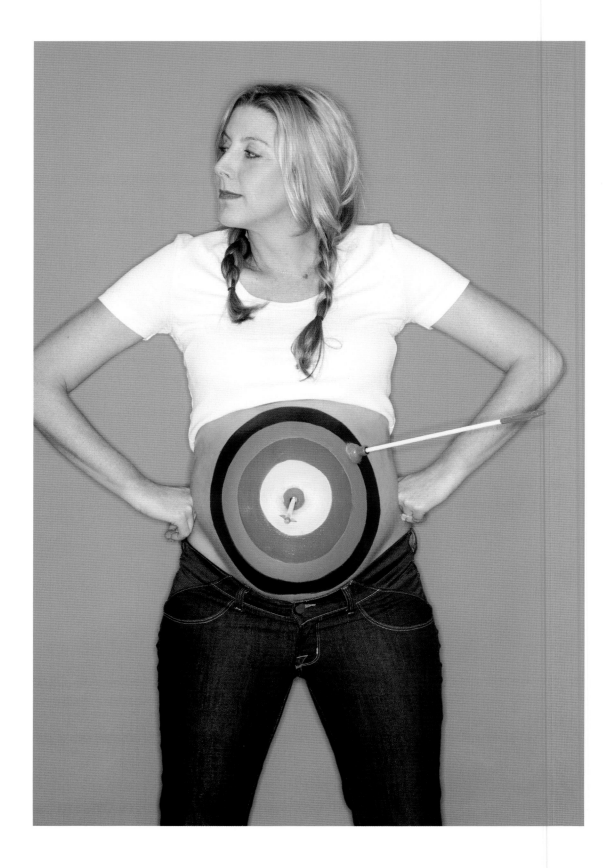

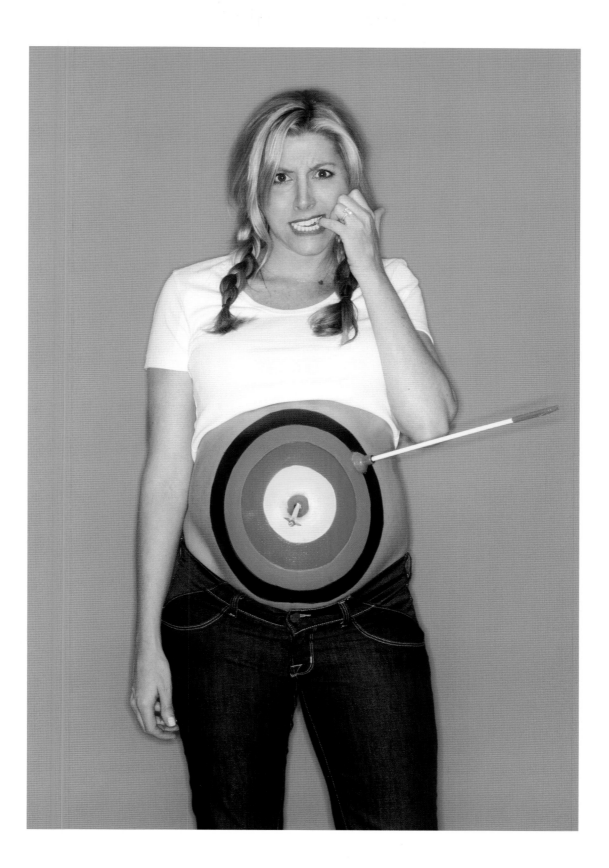

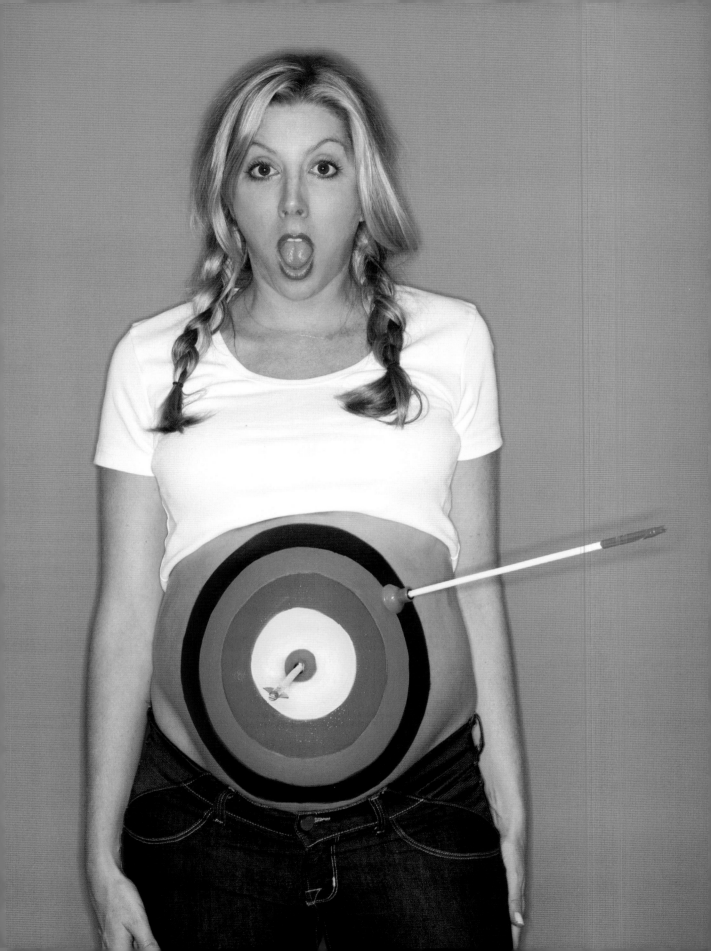

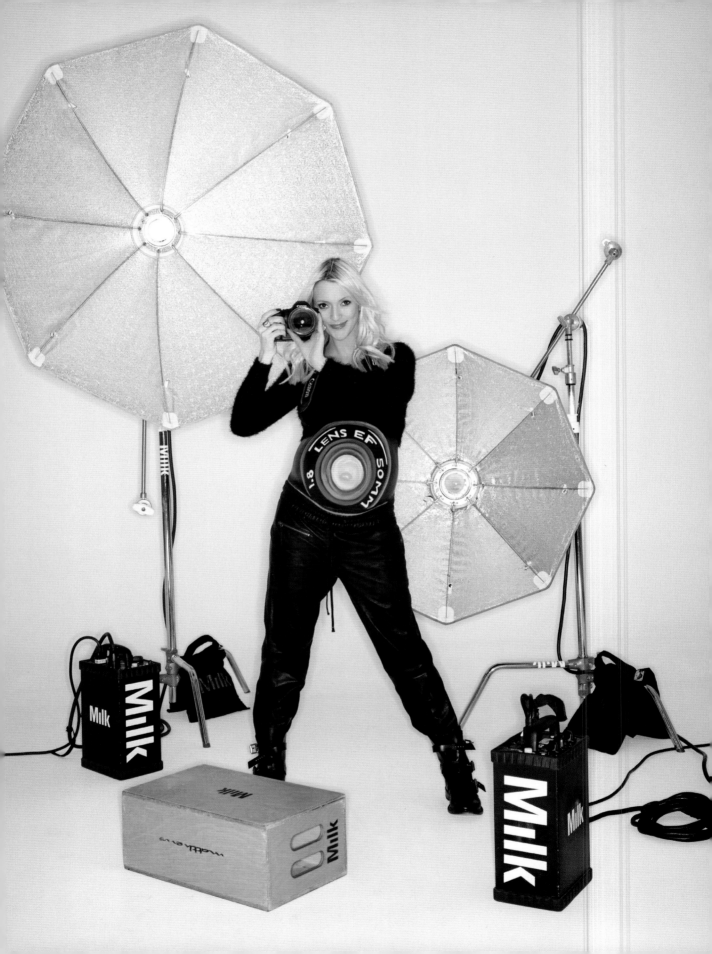

DON'T CHANGE YOUR STYLE. JUST BE YOU WITH A BUMP.

THE BEST THING ABOUT THE BELLY IS THE REWARD.

THE LIFE PRESERVER

**Elsa Pataky** • Model, Actress

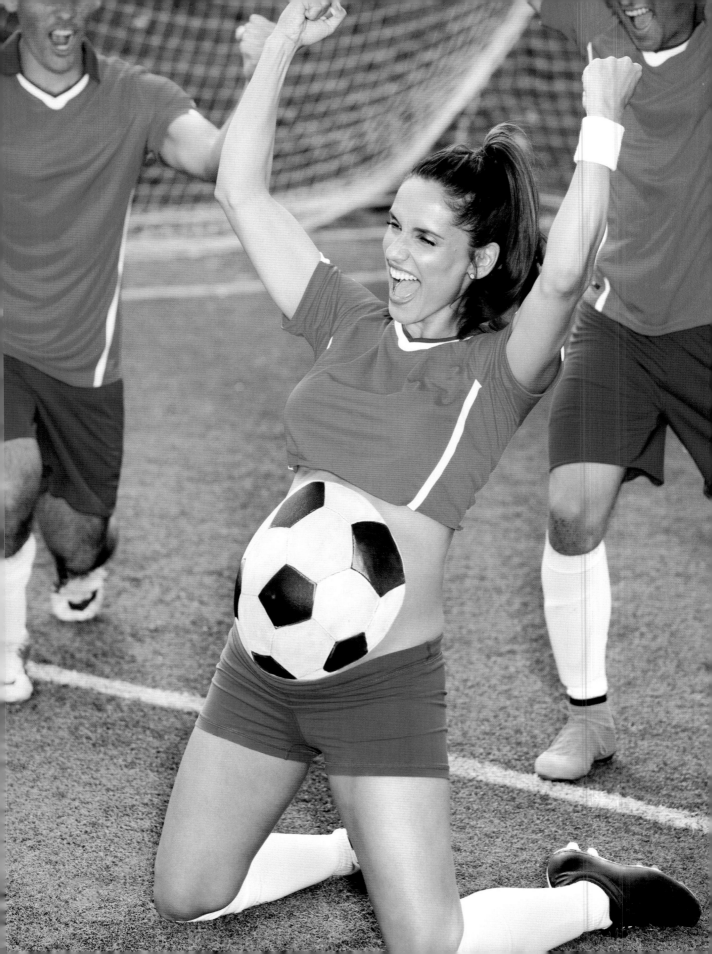

Big belly, small belly?

*You're*

# PERFECT

the way you are.

**SOCCER BALL**

**Leonor Varela** • Actress

Shavon Gihan • Wardrobe Costumer, Film/Video          Breanna Crump • Homemaker

**JELLYFISH**

**Jane Berglund** • Senior Creative Production Manager, Spanx

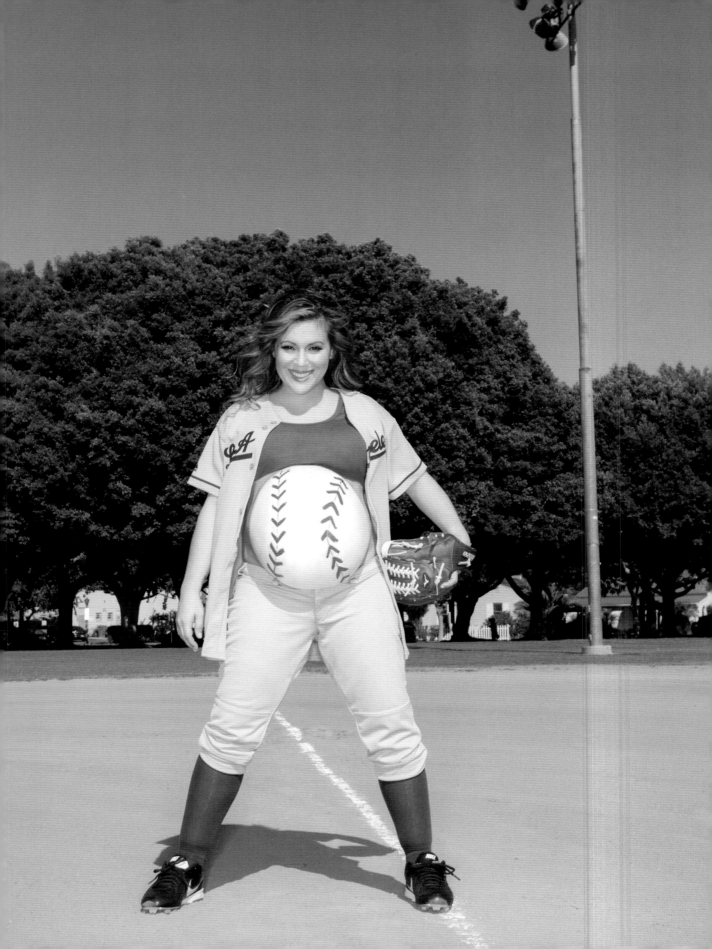

# REMEMBER—
## YOU GOT THIS.

BASEBALL

**Alyssa Milano** • Activist, Host, Actress, Producer

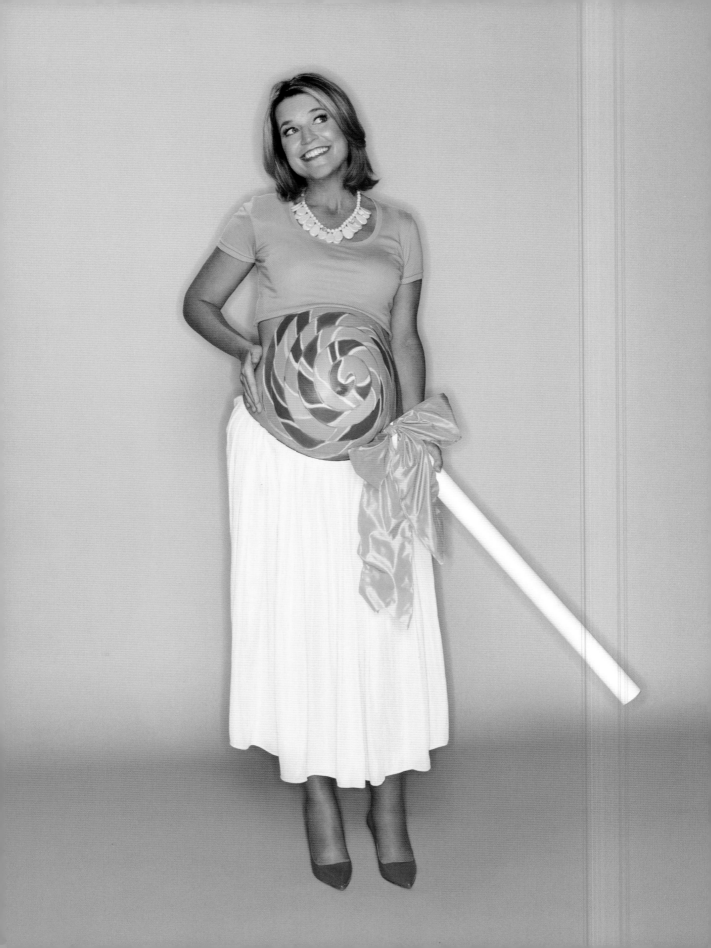

*IT'S EXHAUSTING.*

*Funny.*

*AND 100%*

*PURE BLISS.*

**LOLLIPOP**

**Savannah Guthrie** • Co-anchor of NBC's TODAY

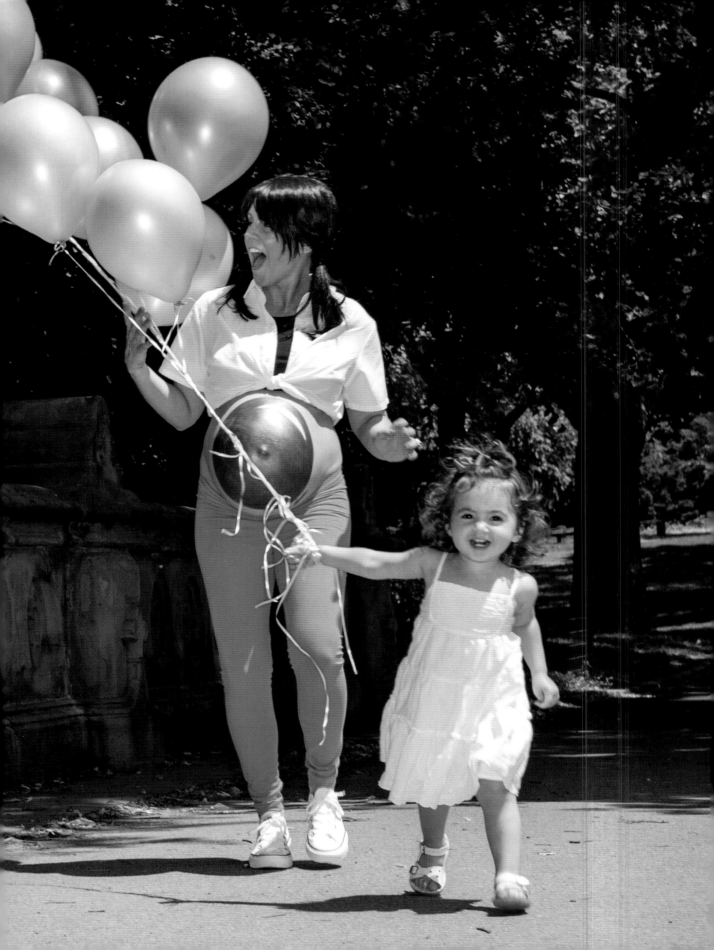

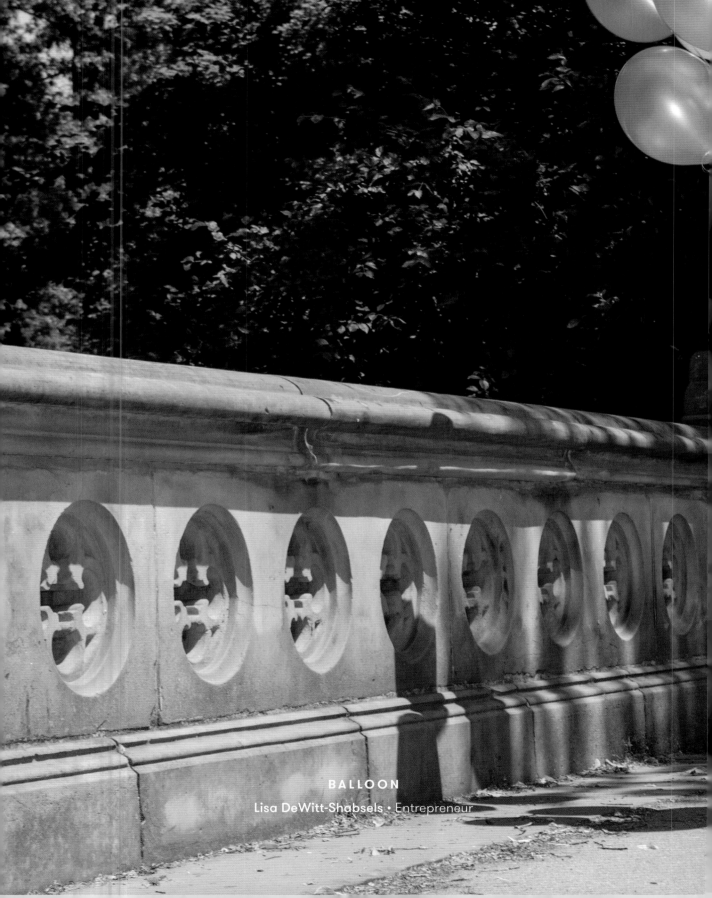

**BALLOON**

Lisa DeWitt-Shabsels • Entrepreneur

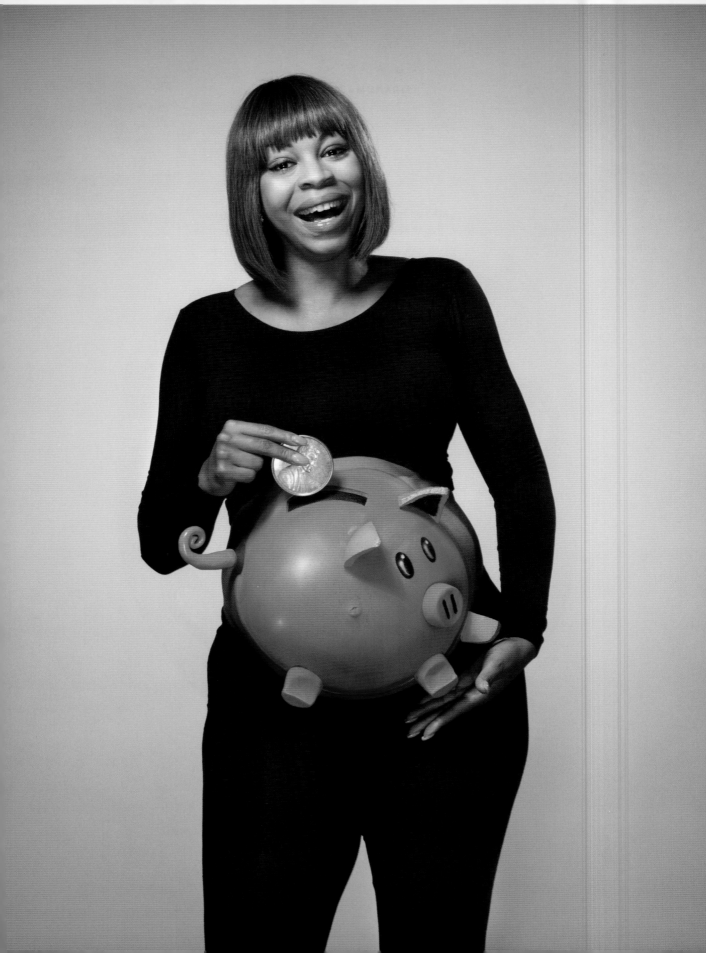

EVERY
PENNY
COUNTS...

when it comes
to helping moms.

**PIGGY BANK**

**Tonya Williams** • Senior Vice President, Bank of America

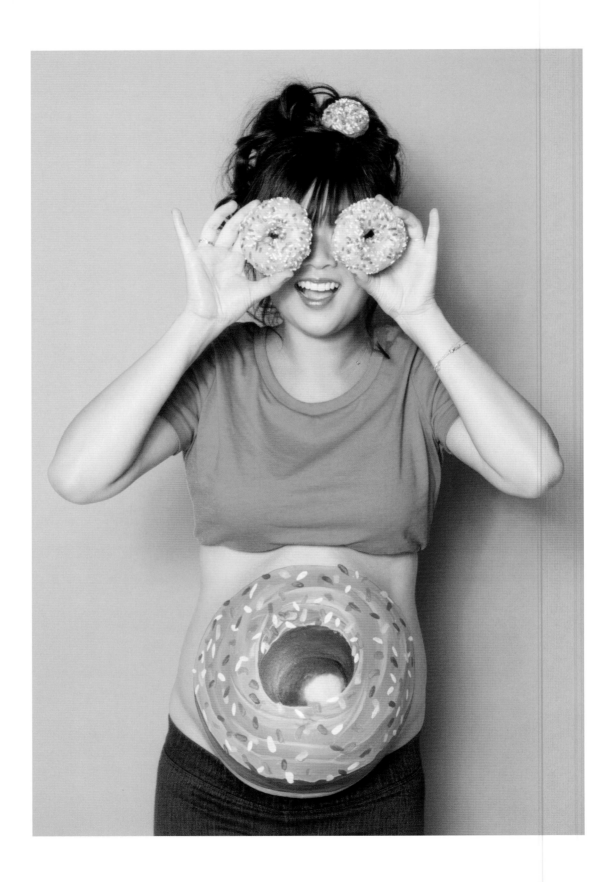

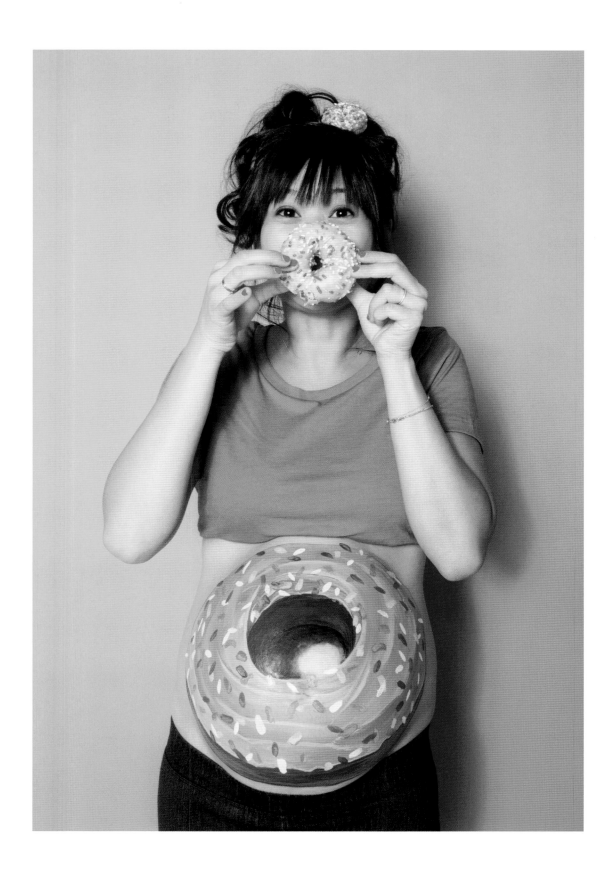

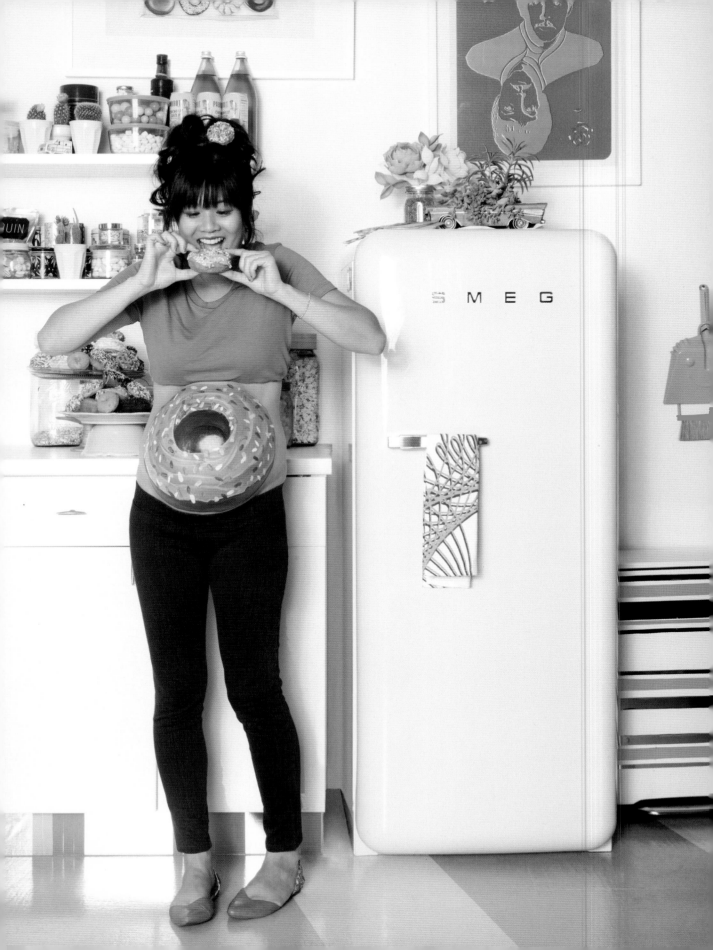

*motherhood isn't about balance—*

# IT'S ALL
# ABOUT THE
# JUGGLE.

DOUGHNUT

**Joy Cho** • Designer and Blogger of Oh Joy!

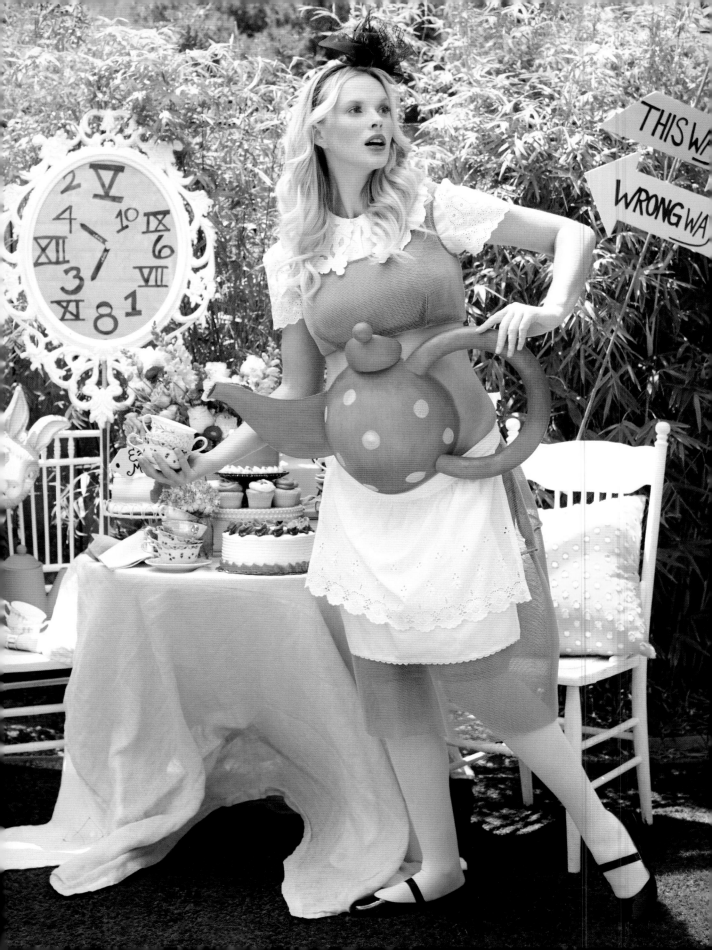

MAMAS
are
MAGICAL

ALICE IN WONDERLAND TEAPOT

Anne V • Model

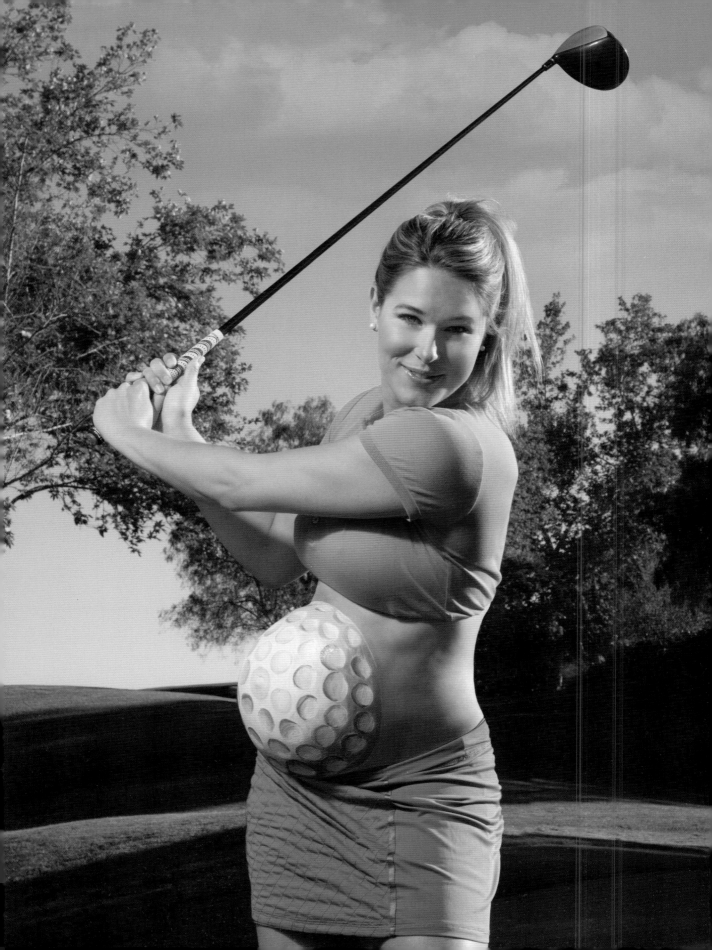

# JUST KEEP GOING AND GROWING...

THE GOLF BALL

**Morgan Beck Miller** • Professional Beach Volleyball Player, Golf Enthusiast

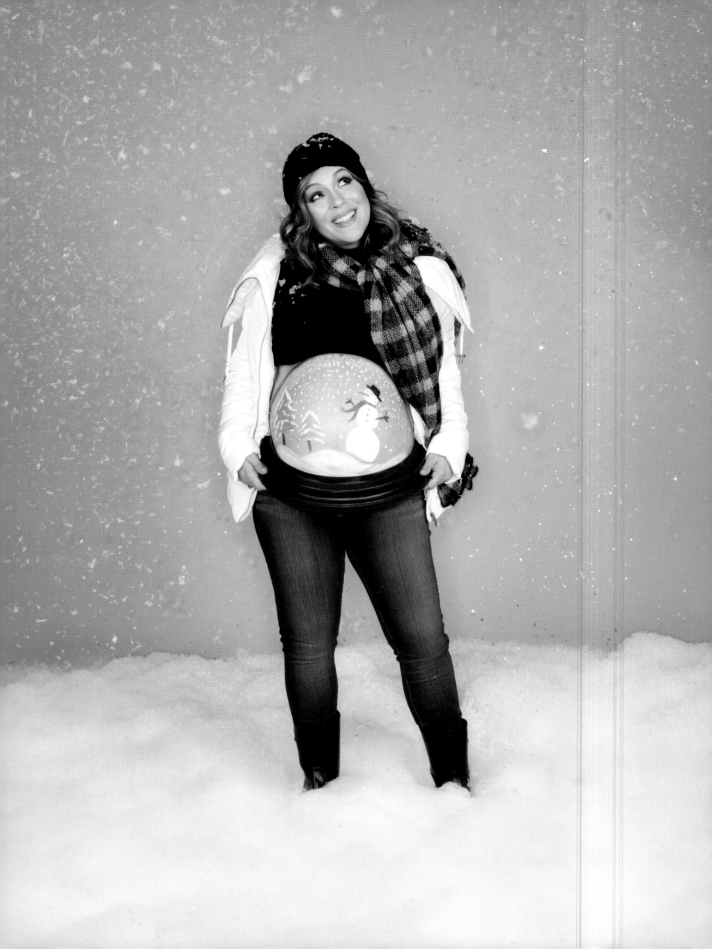

# IT'S UP TO US MAMAS TO CHANGE THE WORLD

**SNOW GLOBE**

**Alyssa Milano** • Activist, Host, Actress, Producer

L→R **Haydee Gamboa** • Insurance Compliance Analyst  **Sasha Von Hanna** • Homemaker
**Britney G. Lewis** • Owner, Home Concierge Service  **Ewelina Zmuda Kaminski** • Logistics
Manager, Spanx  **Melissa Renée Laurenceau** • Event Manager and Producer
**Sharron Falconer** • Homemaker, Actress

THE CATERPILLAR

"WHAT THE CATERPILLAR CALLED THE END OF THE WORLD, THE MASTER CALLED THE BUTTERFLY."
Richard Bach

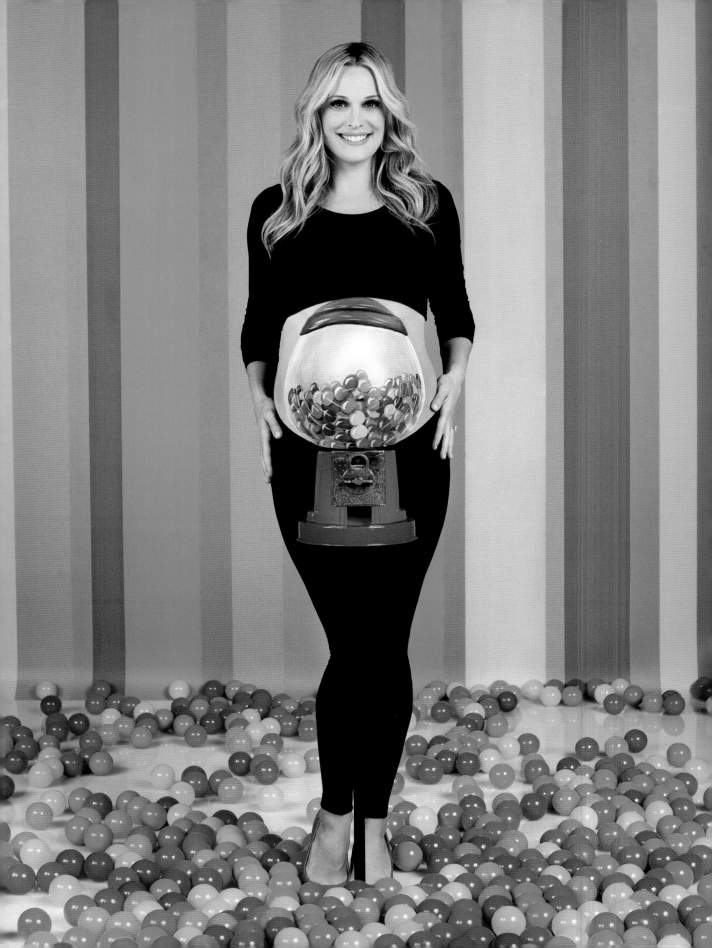

*every belly,*
*every baby,*
*every mom*
*Matters*

BUBBLE GUM MACHINE

**Molly Sims** • Actress, Model

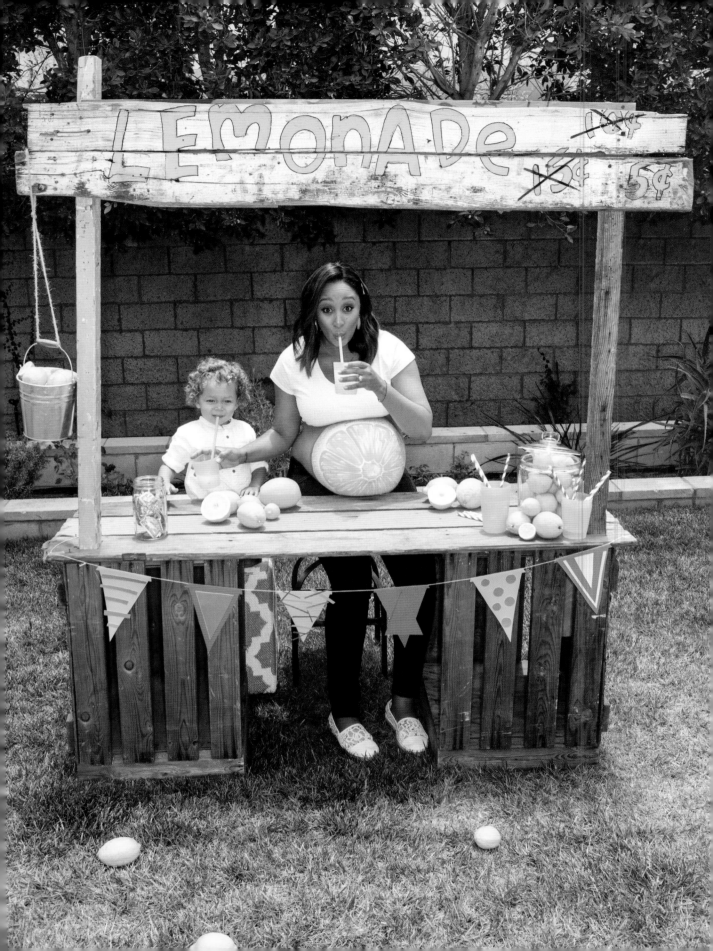

COULD LIFE
GET ANY
sweeter?

**LEMON**

**Tamera Mowry-Housley** • Actress

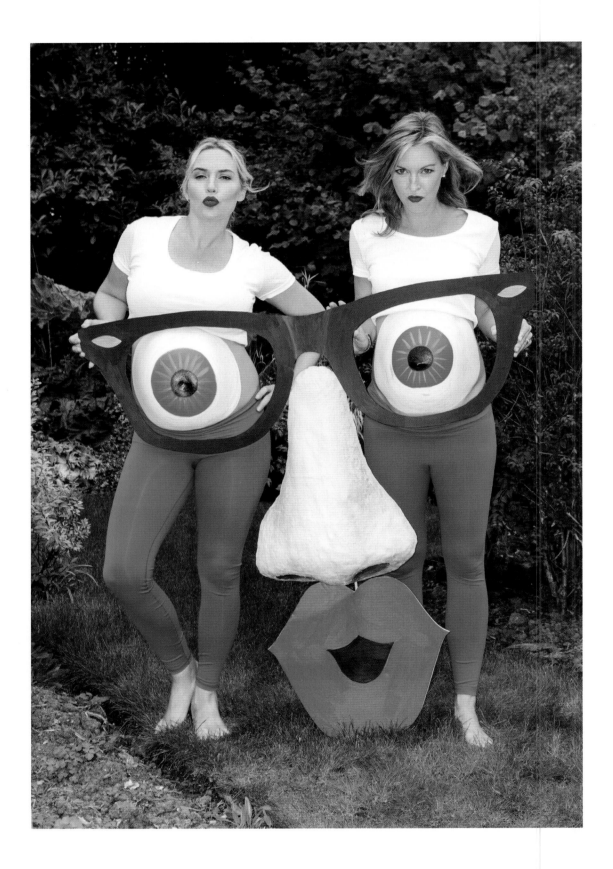

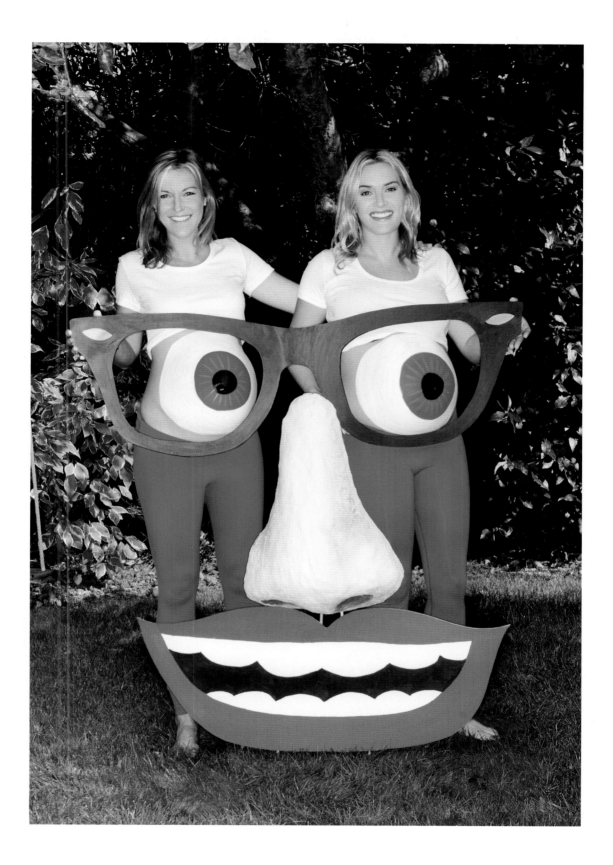

**EYEBALLS**

**Kate Winslet** • Actress   **Niki Perry** • Yoga Instructor

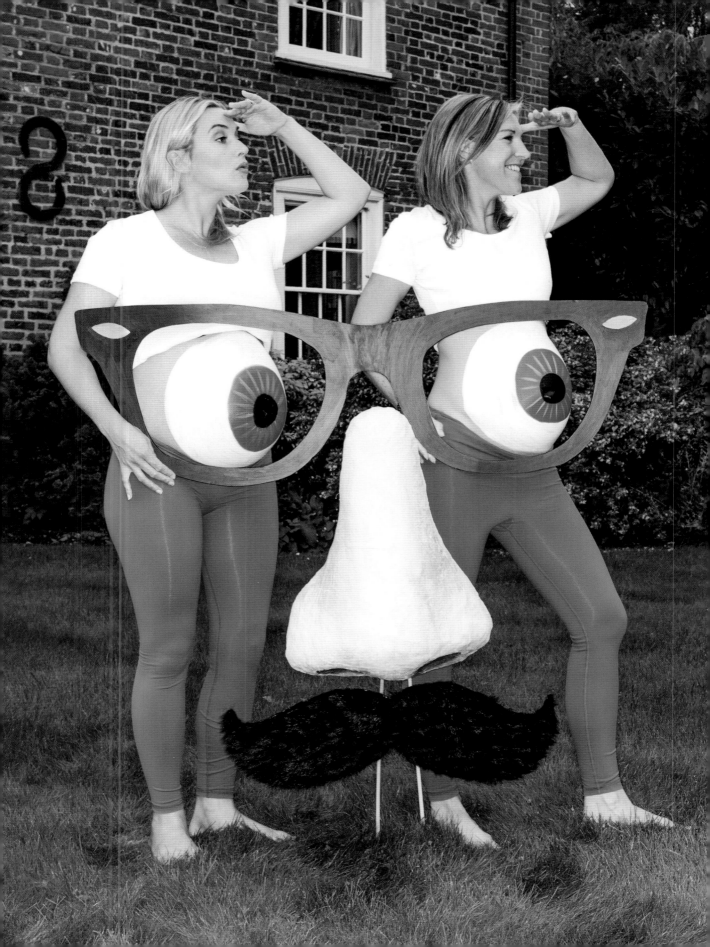

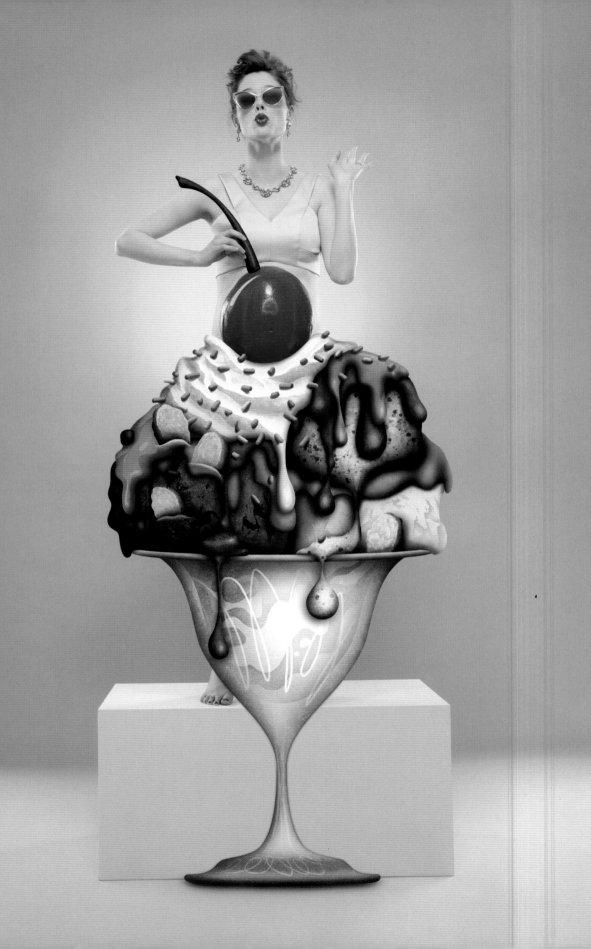

# Ooh la la...

CHERRY

**Coco Rocha** • Model

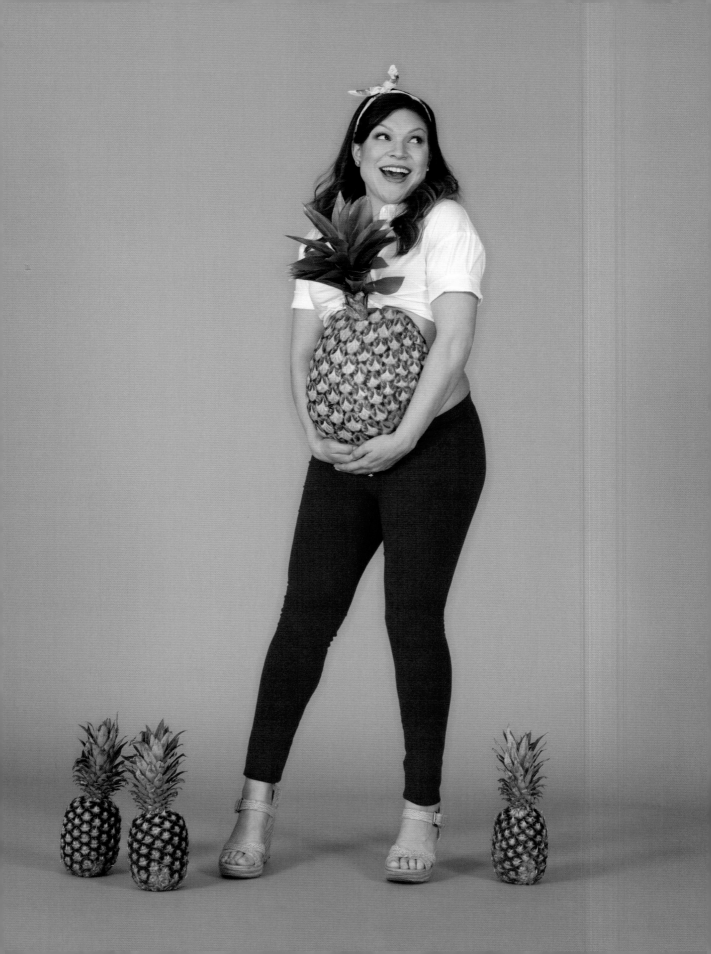

# Supermom?
# NO WAY!
## just you is enough

**PINEAPPLE**

**Willow Padilla** • TV Producer

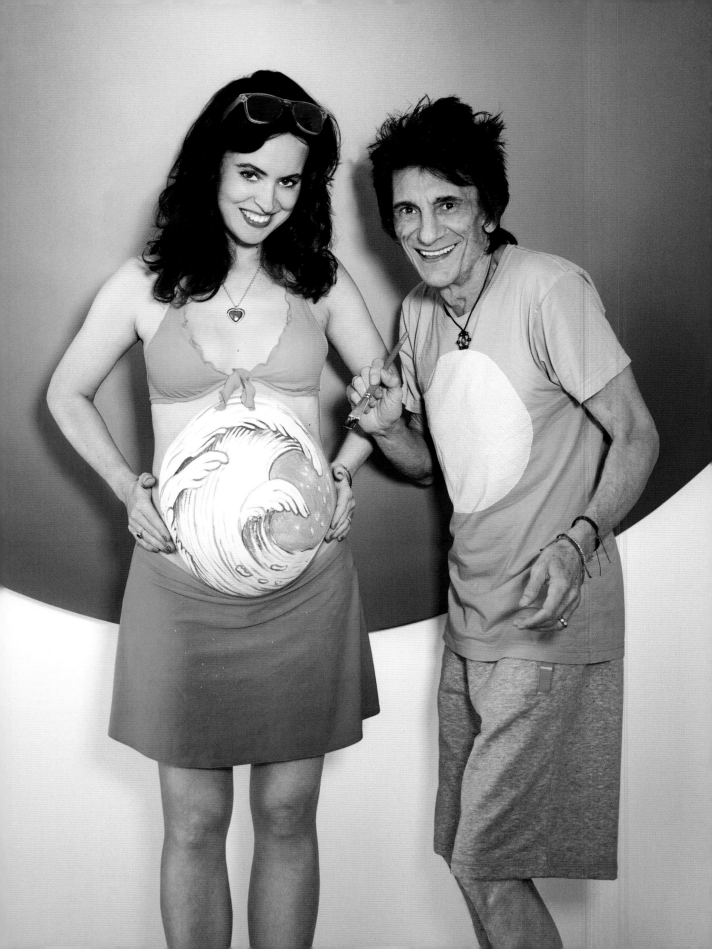

# PEACE
# LOVE &
# ROCK 'n' ROLL

Ronnie painted
Sally's belly! →

TIDAL WAVE

**Sally Wood** • Actress, Producer   **Ronnie Wood** • The Rolling Stones—Musician, Artist

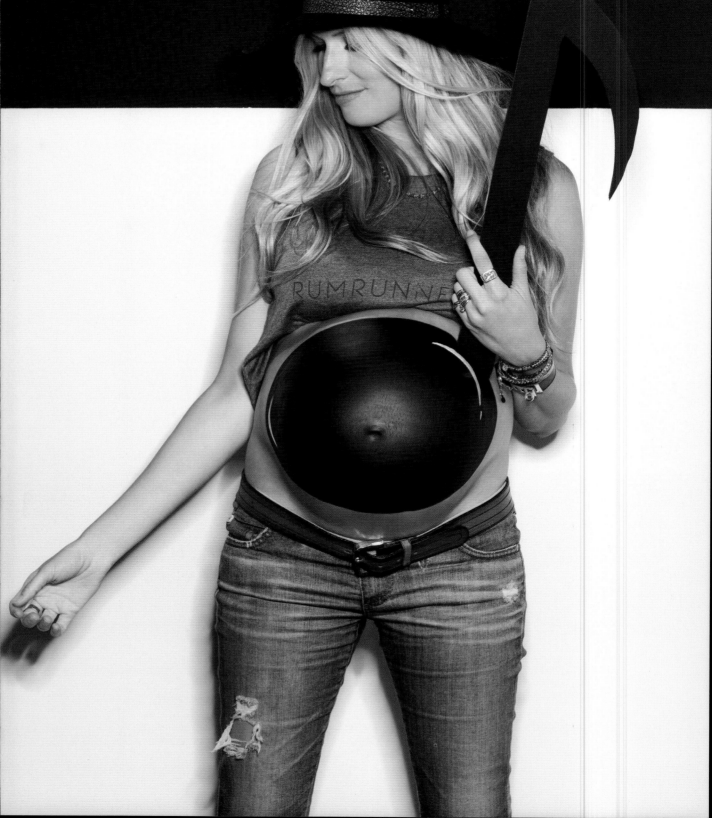

You can do just about anything—

## JUST MAKE
## A LITTLE
## _extra_ ROOM.

**MUSIC NOTE**

**Holly Williams** • Musician, Singer-songwriter

**COCONUT**
Coco Rocha • Model

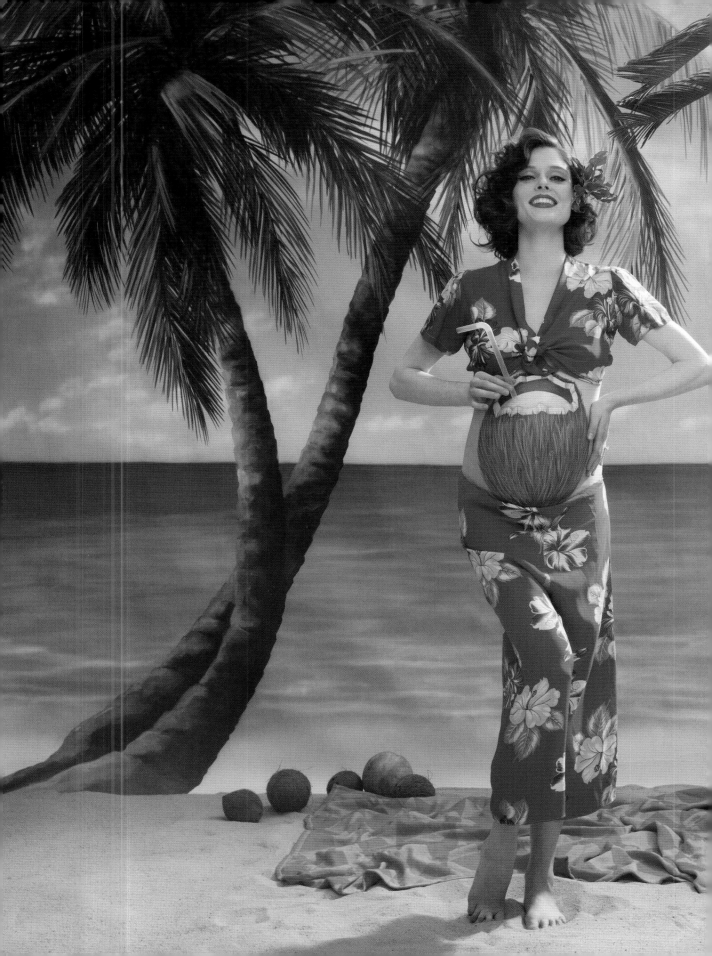

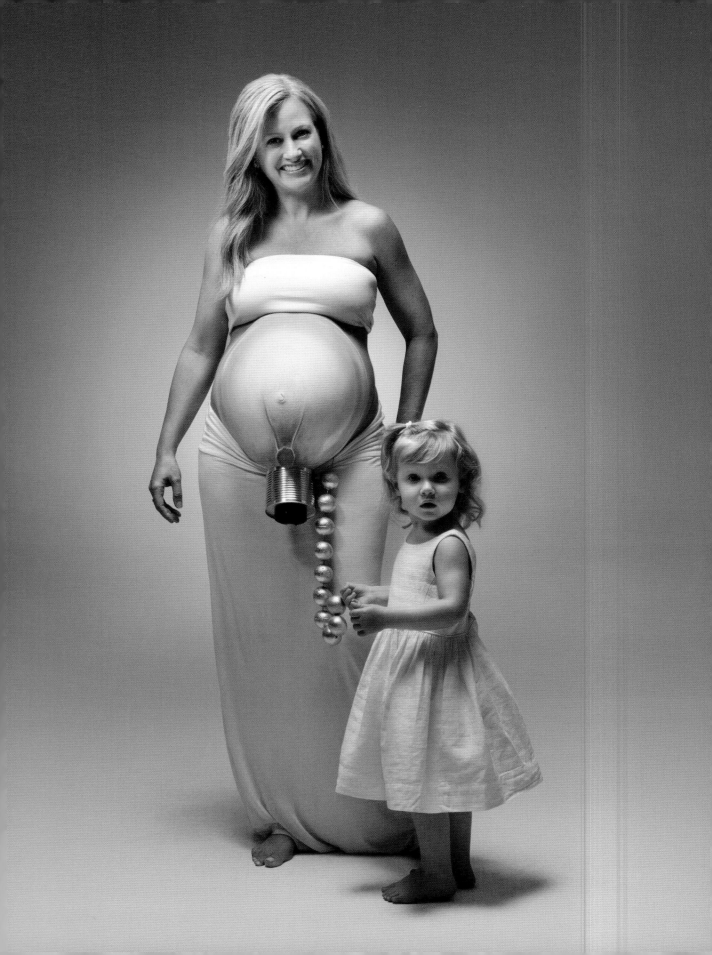

# Mother
## of invention

**LIGHTBULB**

**Jadideah Yarbrough** • Inventor and Designer, Spanx

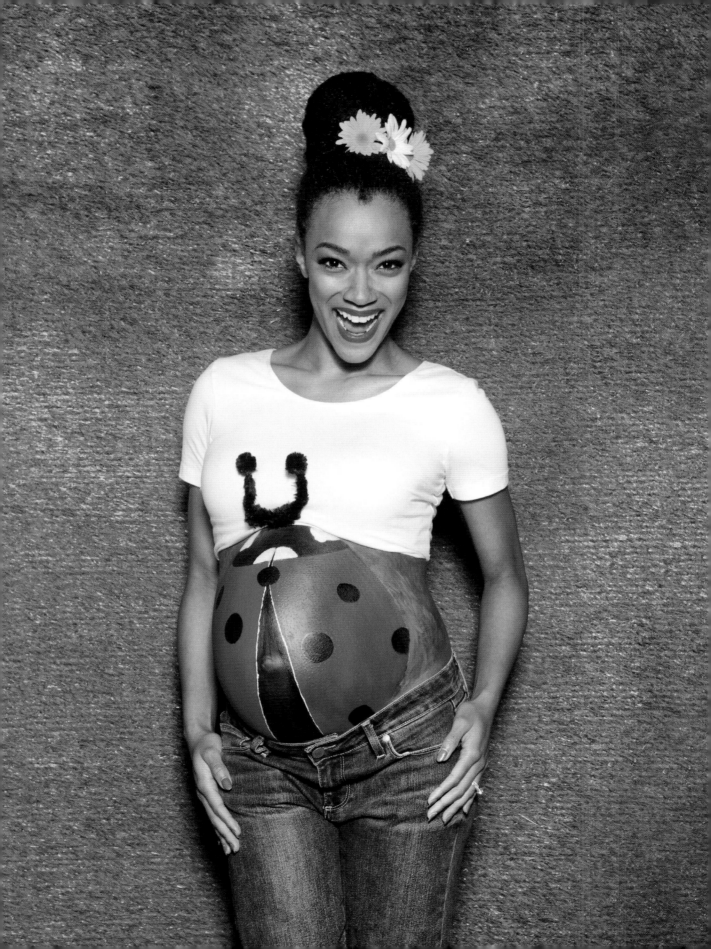

# LUCKY mama!

THE LADYBUG

**Sonequa Martin-Green** • Actress, Producer

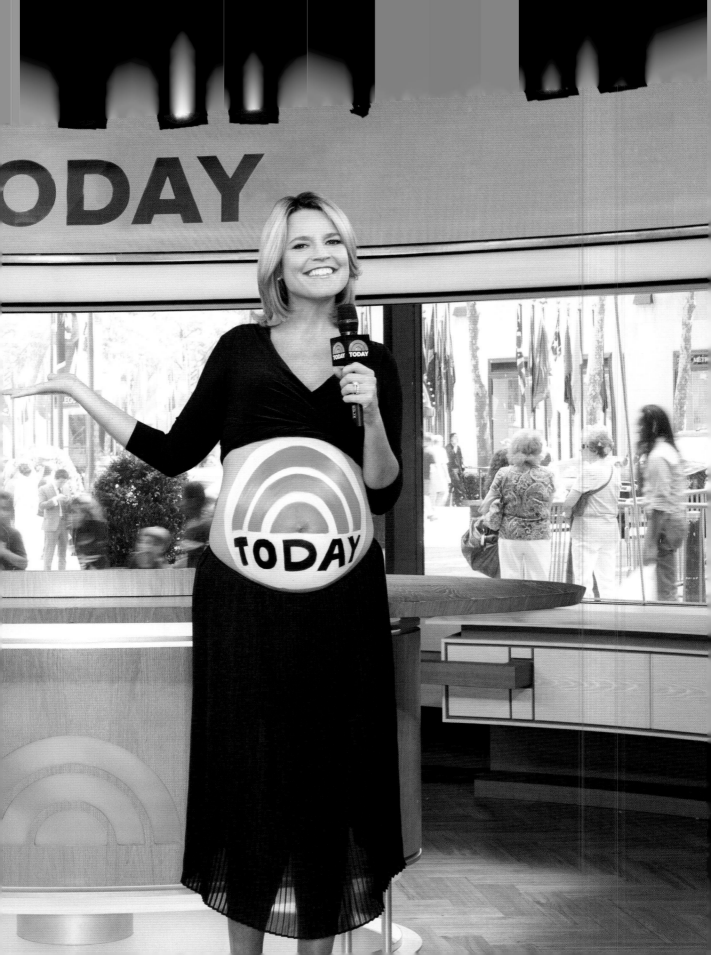

**TODAY SUNRISE**

Savannah Guthrie • Co-anchor of NBC's TODAY

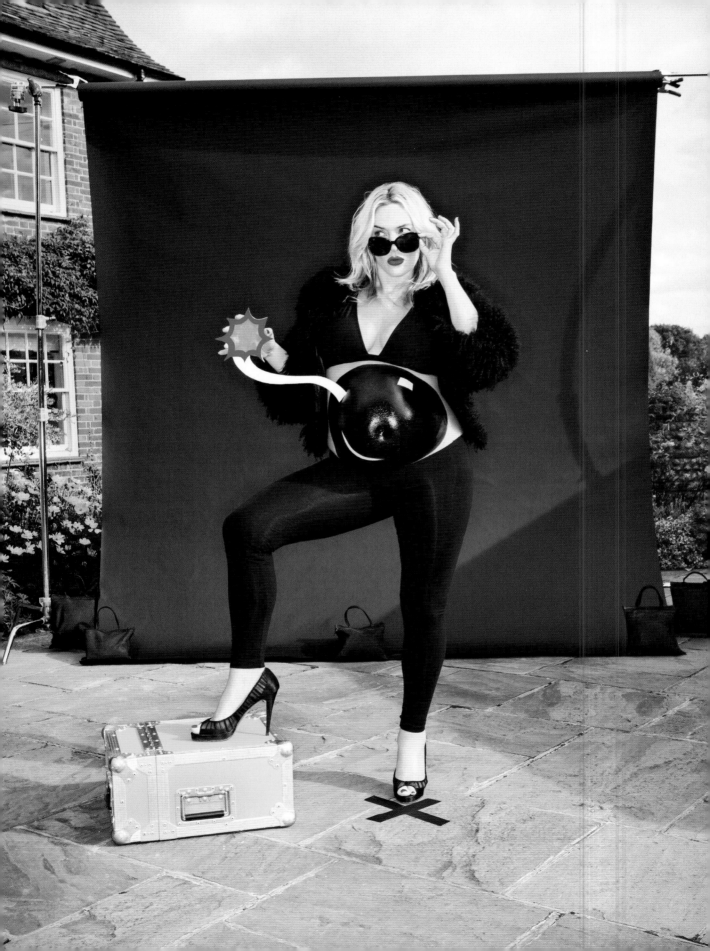

because what's inside
will love you back!

**THE BOMB**

**Kate Winslet** • Actress

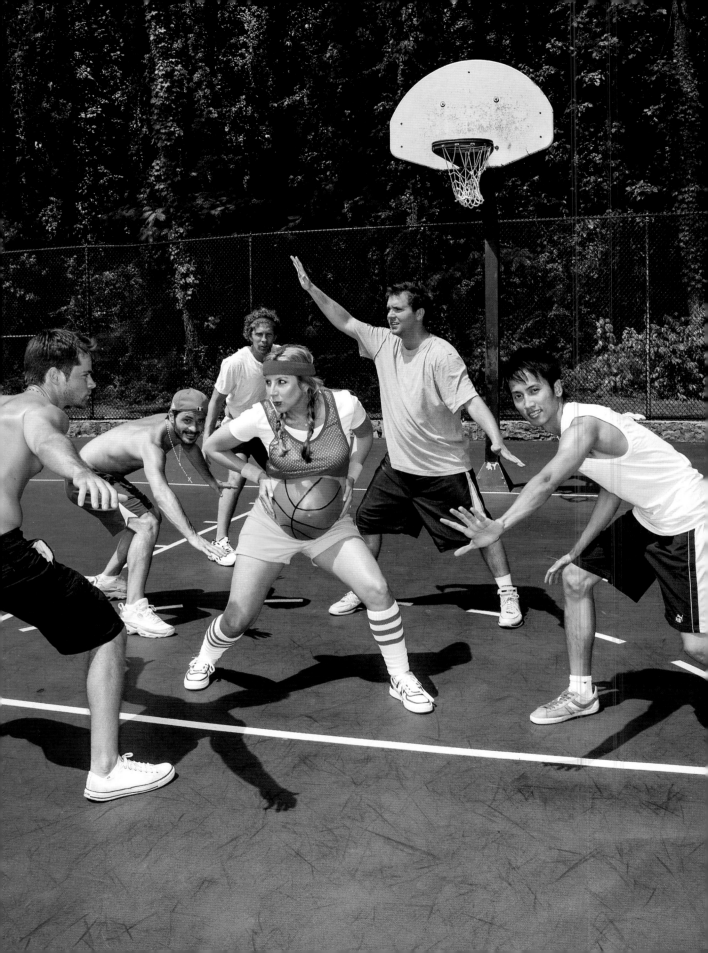

GAME
ON!

BASKETBALL

**Sara Blakely** • Founder/Owner—Spanx and Sara Blakely Foundation

**Be part of the movement!**

Everyone with a belly, especially expectant moms, can paint their
bellies and share their pics on our website, **bellyartproject.org**, and
on social media with the hashtag **#bellyartproject**. We can't wait to
see your own belly work of art! And the more people post and share
their pics, the more awareness we'll raise for mothers in need, helping
moms everywhere have the safe, healthy pregnancies they deserve.

Be fearless, be creative, have fun! Use these big, beautiful bellies of
yours to start a conversation about maternal health, and to let other
women know how much we support and care about them. We're
changing the world one belly at a time, just with paint and
some props.

**It's The Belly Art Project, and you're invited. So show us
what you got, mamas . . .**

#BELLYARTPROJECT

This book will help in three basic ways
to support moms in
having healthy deliveries.

We're helping by directing

# 100%

of this book's
author proceeds to
**MOTHERS IN NEED.**

**transportation vouchers**
to help moms
get to the hospital,

The Sara Blakely Foundation is always
looking for creative ways to help women.
The Belly Art Project is just one example.

**LEARN MORE**
SARABLAKELYFOUNDATION.ORG

**safe "mama kits"**
with clean supplies,

**and better training**
for more midwives
and healthcare workers.

*but what else can we do?*

**99%**

OF MATERNAL HEALTH
ISSUES OCCUR
in the developing
world

where lack of access to
transportation and basic
healthcare has a huge impact.

↓

**Small steps can make a big difference,**

maternal health impacts
the lives of moms,
babies, families, communities
and countries.

↓

helping
to stop up to

**98%**

OF PREVENTABLE
DEATHS

↓

# Together, we can make an even bigger impact.

So we're inviting all moms-to-be (and everyone else!) to join in the fun. Paint your belly and share your photos on bellyartproject.org. The more pictures posted, the more awareness generated, the more will be donated. We also welcome any direct donations, 100% of which will go to help moms.

We're all connected as mothers, children, artists, and inventors. So be creative, innovative, and outrageously playful in bringing your own ideas into the world. In many ways, life is like a pregnant belly, a canvas, something that will only be what it is for a very short moment in time. Make the most of it. Love it. And always, always have fun!

XO,

*Sara Blakely*

producer, agrees to help me bring this book to life, finding places, props, and often the women too. On short notice she creates whatever set and belly idea I dream up. For some reason, ideas for the perfect round objects come to me while sitting at traffic lights. How about a snow globe? A pineapple? A fishbowl? Vintage barbells? (This idea requires two bellies, which gets really interesting!) Cherry on top of a sundae? And on and on. Together we hustle, we conspire, and we create a lot of wacky set pieces out of anything and everything. The craziest idea was the disco ball, the only belly that was not entirely painted, which required us to apply 1,268 crystal mirrors to Amanda Palmer's pregnant belly (but who's counting?). Let's just say it was a wild ride.

Famous and non-famous mothers came together, including women I grew up with, went to school with, built Spanx with, and some total strangers! I approach pregnant women at nail salons, airports, weddings—and after I convince them I'm not crazy, many of them agree to be in the book. What an amazing bunch of women, ranging from actresses, models, teachers, business-women, stay-at-home moms, artists, fashion designers, and military moms. They came together at this incredible moment in their lives, volunteering their time (and bellies) to create the downright hilarious and adorable assortment of objects you're about to see, all in the name of helping other mothers. Also, one very famous man agrees to paint his belly, and another paints his wife's belly. Look out for their cameos—in a million years you will never guess who they are!

Mothers are one of our planet's greatest resources. We need to do everything we can to support them.

while trying to protect a work of art painted on your enormously bulbous belly!)

For the basketball, we drive to a local park where I jump into the middle of an actual basketball game. The players don't speak English; after miming what I want to do, they play along, and the photographer captures the moment. For the watermelon, I walk into a nearby supermarket, head right over to the watermelon display, prop my belly on top of the pile, and walk out. (I can only imagine the person reviewing that week's surveillance video.) For the beach ball, we drive to a local community pool where families are enjoying the day. I see the disbelief in their eyes as a nine-month pregnant woman in a bikini with a beach ball painted on her belly walks up to the diving board, laughing the whole time.

A few weeks later I give these pictures to my husband who absolutely loves them and

says I must do more with the concept. I can't stop thinking about his comment—but life happens, and those pics sit in a drawer for three years. Finally, I decide to see if any other mothers will be up for painting their bellies for a good cause—and the answer is YES!

Creating the book: This book was a true labor of love, and an absolutely wild process—as many of the behind-the-scenes pictures show. Each photo in *The Belly Art Project* is an original work of art. Everything, and I mean *everything*, you see is created entirely from scratch. And let me tell you, it's not easy to produce art on super pregnant women.

First, you have to find women who are eight or nine months pregnant—and work really fast. (A couple of times we didn't work fast enough, and one of those is included!) My childhood friend Chelsea, a talented

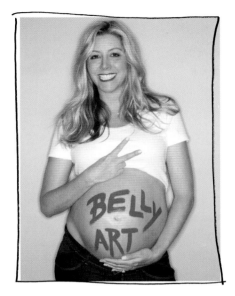

# Hi! Thank you for buying this book. You just helped a mom.

This Belly Art Project-turned-book celebrates the mother in all of us—the beautiful, creative, inventive spirit that connects everyone. After all, they call it Mother Nature and the Mother of Invention for a reason—it's universal.

Mothers are one of our planet's greatest resources. We need to do everything we can to support them. Through the Sara Blakely Foundation I'm always dreaming up creative ways to help women, and The Belly Art Project is one of them. 100% of the author proceeds from this book will go to Every Mother Counts, Christy Turlington Burns' non-profit organization. It's a gift I'm happy to make.

**The story behind the book:** Three days before I deliver my son in June 2009, I wake up in the middle of the night with a creative urge to turn my big belly into round objects. I see my belly as a glorious,

but temporary canvas. Will it ever be this way again? How can I capture this moment in time in a fun and playful way? At 3 AM, I lean over and scribble on a piece of paper: watermelon, beach ball, basketball, Mr. Potato Head, bullseye, and then naturally … I fall back asleep.

The next morning I decide to give in to this belly painting idea for three reasons: I want to give my husband a creative baby gift; I want to capture this moment in time with my belly in an out-of-the-box, lighthearted way; and I want my son to have these pictures as a keepsake in his baby book. From that moment on, everything happens fast: I call a friend who agrees to paint my belly at the last minute, and we enlist the help of a photographer. We race around town finding locations to match the objects painted on my belly, one by one. (It's hard enough to get in and out of the car when you're about to give birth. Just imagine doing it

This book is dedicated to my wonderful mom,
Ellen, who taught me the value of creativity
and the importance of showing up. I love you!

And to the many inspiring women who believed
in this crazy idea, showing up to help other
moms—using their creativity, passion, humor,
bellies and love along the way.

THE BELLY ART PROJECT. Copyright© 2016
by Sara Blakely. All rights reserved. Printed in China.
For information, address St. Martin's Press,
175 Fifth Avenue, New York, NY 10010.

www.stmartins.com

The Library of Congress Cataloging-in-Publication Data
is available upon request

ISBN 978-1-250-12136-3 (hardcover)
ISBN 978-1-250-12137-0 (e-book)

Our books may be purchased in bulk for promotional,
educational, or business use. Please contact your local
bookseller or the Macmillan Corporate and Premium
Sales Department at 1-800-221-7945, extension 5442, or
by e-mail at MacmillanSpecialMarkets@macmillan.com.

First Edition: October 2016

10 9 8 7 6 5 4 3 2 1

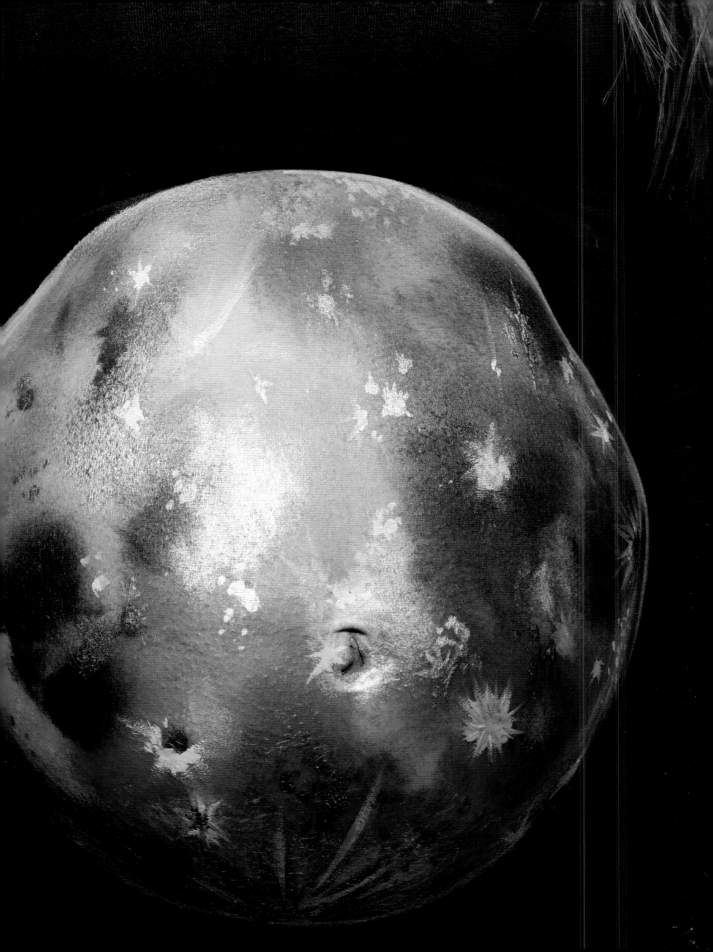